# Black Children's Literature
# Got de Blues

# AFRICAN AMERICAN LITERATURE AND CULTURE

**Expanding and Exploding the Boundaries**

Carlyle V. Thompson
*General Editor*

Vol. 11

PETER LANG
New York • Washington, D.C./Baltimore • Bern
Frankfurt am Main • Berlin • Brussels • Vienna • Oxford

Nancy D. Tolson

# Black Children's Literature Got de Blues

## The Creativity of Black Writers & Illustrators

PETER LANG
New York • Washington, D.C./Baltimore • Bern
Frankfurt am Main • Berlin • Brussels • Vienna • Oxford

Library of Congress Cataloging-in-Publication Data

Tolson, Nancy.
Black children's literature got de blues: the creativity
of Black writers and illustrators / Nancy D. Tolson.
p. cm. — (African American literature and culture:
expanding and exploding the boundaries; v. 11)
Includes bibliographical references and index.
1. American literature—African American authors—History and criticism.
2. Children's literature, American—History and criticism. 3. Children's literature,
American—Illustrations. 4. African American authors—Aesthetics.
5. African American illustrators—Aesthetics. 6. African Americans—Race identity.
7. Melancholy in literature. 8. Sadness in literature. 9. African American children
in literature. 10. African Americans in literature. I. Title.
PS153.N5T66   809'.89282'08996—dc22   2007051202
ISBN 978-0-8204-6332-2
ISSN 1528-3887

Bibliographic information published by **Die Deutsche Bibliothek**.
**Die Deutsche Bibliothek** lists this publication in the "Deutsche
Nationalbibliografie"; detailed bibliographic data is available
on the Internet at http://dnb.ddb.de/.

Cover art and author photo by Kenneth A. Tolson, Jr.

The paper in this book meets the guidelines for permanence and durability
of the Committee on Production Guidelines for Book Longevity
of the Council of Library Resources.

© 2008 Peter Lang Publishing, Inc., New York
29 Broadway, 18th floor, New York, NY 10006
www.peterlang.com

Printed in the United States of America

# • CONTENTS •

## • ACKNOWLEDGMENTS •

The sign on I - 81 says: Shoulders Are For Emergencies Only . . .Ride me, Poem . . . I think I've got the blues . . .
Nikki Giovanni (2002, 15)

I-80 led me to the University of Iowa where I found the wisdom and patience of many scholars. Donnarae MacCann taught me what was missing in the field of Black children's literature and how to find it. She soothed my blues many a day by telling me stories and serving me rootbeer floats. My love for bound periodicals is from Donnarae's search games that she called assignments.

I am grateful for the continuous wisdom, guidance, musical expertise and friendship that I have had with William Welburn. I was taught another way to study Black culture, which included the blues. I warned you in the beginning that this was going to be a rollercoaster ride. I pray that whatever therapy sessions you might need in the future won't be because of me. Thanks for holding on tightly, adjusting when necessary, while accompanying me on this blues journey.

James Marshall, at the University of Iowa, thanks for your directions and patience for taking part in my matriculation throughout the groundwork of this book.

To my favorite sister, Harriet Harris and my sistah girlfriends Tracie McKissac and Kafilah Malik Mc Gurdy—three beautiful souljahs dealing daily with blues children. You all are my inspiration and I adore you all for teaching, caring, and protecting one of our most valuable natural treasures placed upon this earth—our children.

To my family that raised me on Black wealth and assured me that all was possible as long as I kept the faith, Frances & Walter Harris Jr., Marguerite Tolson, and Estella Bradley, thank you for all the phone calls, prayers, supplying my habits when I could no longer afford them and for keeping my KATs during those long hot blues summers.

I want to thank the University of Iowa, Illinois State University's Department of English and Mitchell College for allowing me to expand and grow intellectually through teaching so many wonderful children's literature courses. And I thank the students for challenging me and teaching me along the way.

I want to express my deep appreciation to my editor, Carlyle V. Thompson, who really made me see how important it was to bring forth my passion by inserting my voice to this work.

Much love goes out to the wisdom of Darwin Henderson, Dianne Johnson, Katherine Capshaw Smith, Violet Harris, Rudine Bishop, and Michelle Martin. These scholars are truly to be respected on high in the field of Black children's literature. I also thank Andrew Sekou Jackson; Queens produced a king and a souljah in the field through being one of the keepers of the books.

Eleanora E. Tate, Evelyn Coleman, Jacqueline Woodson, Kwame Dawes, and Tony Medina jumped off the pages years ago to become wonderful friends and true blessings in disguise. Your artistry makes me want to kiss your minds. Thanks for allowing me to have my cake and eat it too.

Zora Neale Hurston, Langston Hughes, Mary McLeod Bethune, John Steptoe, Tom Feelings, and Virginia Hamilton; their wisdom, visions and determination to make a difference in this world have been a shining star for me to follow. To those that have left a beautiful deep mark on my life mold and spirit; Grace Wofford, Deborah Harris, John Stewart, Mindret Spencer, and William Tolson, Jr., I am grateful for what you have given me ~ homemade love, appreciation for coffee, loud laughter, big feet, creativity and the courage to step out on faith.

To my sistah girlfriends that have been there when I have had the blues, Edris Cooper - Anifowoshe, Rhonda Elliott, Sheri Gilmer, Melda Beaty, and Tracie Allen, I love you all madly. To my young sistahs that are soon to be artist / scholars, Erica Thurman and Lauren Kim, thanks for your energy, laughter, radicalism, and the unconditional love you have given me. I look forward to reading each book and article you produce.

I been blessed to have a sane half, Kenny, who believed in my dream enough to pack up the family and drop us off in a field of dreams. We made it through rough bi-monthly visitations, late night cappuccinos, sleeping on the sofa just to keep me company in a five hundred square feet palace. Overseas phone calls, overseas visits, surviving an active son (winner of three broken limbs), being my nurse, high school and college graduations, and so many other victories have all been a part of our adventure. And now it is your dream we are following; you are so worth a thousand mile move to a new field of dreams. Whoa, what a ride!

The three children, Kenneth Allen, Kinnethia Amye and Kindyl Annestine, that for the past twenty-two years have raised Kenny and me, thanks for your guidance, your laughter, old spirits, and energy. You are the reason for my entering grad school and focusing on Black children's literature. I dedicate this book to my favorite KATs. I learned through this literary journey that your blues ain't like mine.

# The Blues Understood

Besides,
They'll see how beautiful I am
And be ashamed—

—Langston Hughes (1954)

Black folk art tradition is the artistic expression of the Black experience in the United States that originated from a culture that used oral and visual arts to pass on their history, beliefs, traditions and stories. Africans brought to the United States during slavery configured their once freed experiences into their enslaved existence by creating music, poetry, stories, and visual artwork that formed a new cultural identity. This expressional portion of the Black experience in the United States evolved into a Black aesthetic that is identified through music, literature and the visual arts.

Black children's literature has been a venue that has housed historical, social, political and spiritual portions of the past through the use of stories as creative record keepers that could be handed down to future generations. Over one hundred years Black people have written and illustrated stories for Black children in order for them to know the historical backgrounds and heroic Black figures that set down monumental tracks throughout the world. Through Black children's literature Black folk art tradition continues. And like Black "adult" literature it covers many of the same aesthetic qualities, one of which is the blues aesthetic.

This book is an examination of various Black writers and illustrators that have set down an aesthetic stylization that includes a blues spirit that can be identified through critical writings by scholars that have specifically defined a blues aesthetic culture that can be found within Black literature, poetry and the visual arts. It must also be known that Black children's literature will not be able to identify with *all* the elements of the blues aesthetic within Black "adult" literature because all are not appropriate, but new concepts of the blues aesthetic have been developed to reflect a cultural understanding of

Black childhood. The connection between sociology and the blues aesthetic can be defined through the functionality of Black art. Ron Karenga (1972) defines the bridge that connects literary aesthetics with literary sociology:

> It must be functional, that is *useful* as we cannot accept false doctrine of "art for art's sake." For, in fact, there is no such thing as "art for art's sake." All art reflects the value system from which it comes. For if the artist created only for himself and not for others, he would lock himself up somewhere and paint or write or play just for himself. But he does not do that. On the contrary, he invites us over, even *insists* that we come to hear him or to see his work; in a word, he expresses a need for our evaluation and/or appreciation and our evaluation cannot be a favorable one if the work of art is not first functional, that is, useful. (32)

Black children's literature recognizes the existence of the Black child in the United States and validates their importance in the world. These books are tools of enrichment that demonstrate cultural understanding for all children.

Several of the essays in Asa Hilliard's *The Maroon Within Us* (1995), focus upon the insensitive treatment of Black children within their educational experience. These children are misinformed about their own culture and are many times saturated with European and White American literature and culture (58). Hilliard witnessed a trend in literature that either omitted historical facts from cultural literature or distorted the truth. Hilliard believes that the improvement of education for the Black child lies in placing literature that has been written for them that can project a clearer cultural aesthetic expression. These writers are necessary in order for children to receive a more realistic view of the world that surrounds them. This can only be done when more Black children's books are accepted inside more classrooms throughout the country and displayed more often within school libraries and bookstores.

> Our children will never be academically and culturally excellent until our adults are. African Americans have a special need. We need a massive mobilization of all of our resources toward the reeducation of ourselves and those who would lead the children. Our own memories must be restored. Our own hunger for self-determination as a people must be resurrected. As educators, we must stand on *dry ground*. (114)

The purpose of this book is to educate adults on the literature that could uplift a child that has felt ignored, mentally abused and confused from exposure to books that are invisible to that child's identity. Adults have to be

the catalyst for a movement to re-evaluate and restock the shelves with books that encourage and agitate positive thoughts and actions into Black children's lives. From 1960 to the present I selected Black children's picture books that were written and illustrated by Blacks that contain the literary elements of the blues aesthetic. The focus is upon Black artists that have consciously or subconsciously placed within their literature for children artistic expressions of being Black in the United States that can be explained as an aesthetic exploration of the human experience. This study is not entirely from Black children's literature or research by scholars but also from my own childhood experience in the United States. I cannot remember a time when I did not know the blues. As a Black child living in Detroit, being raised in a house filled with music, I heard blues, jazz, R&B, and country. I knew what it meant to have the blues through listening to adult conversations and stories told. I understood Lucille Clifton's poem "Good Times" because it was celebrating getting over the bad times and consciously appreciating a good moment. Through youthful consciousness I knew when the bills were paid, a number hit (either boxed or straight), or when new sneakers were bought due to a win at the track. It was a good feeling to have my mother in the kitchen, family and friends over on a Saturday or Sunday afternoon, food and laughter flowing while music and conversations filled the house. Good times were also present when friends were on the porch, playing the telephone game or a *Mr. Softy's* ice cream truck drove down the street and we all had money to buy at least a single swirl. And when I look back upon those moments in my childhood I know without a doubt that those were blues moments that could reflect Clifton's words:

> oh these is good times
> good times
> good times
> oh children think about
> good times. (38)

This is not to say that there are very few good times in Black childhood because that could vary from household to household, as it does with any people. But what is evident is that there are moments when a *good time* is

realized, whether it be an everyday occurrence or not; it is just a moment that is to be recognized and celebrated.

It is important to recognize the way in which Black writers share their personal stories from childhood, which expands Black consciousness to Black childhood. There are many Black writers that have shared their childhood memories or created childhood moments within their novels that deal with racial awakenings. Stories detailing the initiation of a child's racial reality slap that informed them that color really did matter and that they are definitely Black and to some inferior. There is a time in their youth when innocence is redefined and the passages within Langston Hughes's *Black Misery* (1969) are both amusing yet a painful part of reality. "Misery is when your white teacher tells the class that all Negroes can sing and you can't even carry a tune" (7). This passage is part of Hughes' autobiography *The Big Sea* (1940). It was under such an assumption that he began writing,

> I was the Class Poet. It happened like this. They had elected all the class officers, but there was no one in our class who looked like a poet or had ever written a poem. There were two Negro children in the class, myself and a girl. In America most white people think, of course, that all Negroes can sing and dance, and have a sense of rhythm. So my classmates, knowing that a poem had to have rhythm, elected me unanimously – thinking, no doubt, that I had some, being a Negro. (24)

It was not as an adult that W.E.B. Du Bois began to feel racially different but during his youth when he was awakened and motivated by his brown-ness to soar above his classmates.

> I remember well when the shadow swept across me. I was a little thing, away up in the hills of New England . . . In a wee wooden schoolhouse, something put it in the boys' and girls' heads to buy gorgeous visiting – cards – ten cents a package – and exchange. The exchange was merry, till one girl, a tall newcomer, refused my card, – refused it peremptorily, with a glance. Then it dawned upon me with a certain suddenness that I was different from the others; or like, mayhap, in heart and life and longing, but shut out from their world by a vast veil. I had thereafter no desire to tear down that veil, to creep through; I held all beyond it in common contempt, and lived above it in a region of blue sky and great wandering shadows. That sky was bluest when I could beat my mates at examination – time, or beat them at a foot-race, or even beat their stringy heads. (8)

Du Bois eloquently describes his development into double consciousness that was caused by the behavior of a young classmate that brought forth the hatred of racism by rejecting the exchange of a greeting card with him. Childhood is not exempt from the pains of racism. Through the childhood experience of Du Bois a mechanism was turned on inside of him that did not pull him down but lifted him up to a challenge – not to be like his white classmates but to always strive to be better.

In James Weldon Johnson's *The Autobiography of an Ex-Coloured Man* (1912) the depiction of a fictionalized character that is awakened into his blackness at the age of eleven is quite different than Du Bois' because this young boy is not aware that he is not white.

> One day near the end of my second term at school the principal came into our room and, after talking to the teacher, for some reason said: "I wish all of the white scholars to stand for a moment." I rose with the others. The teacher looked at me and, calling my name, said: "You sit down for the present, and rise with the others." I did not quite understand her, and questioned: "Ma'm?" She repeated, with a softer tone in her voice: "You sit down now, and rise with the others." I sat down dazed. I saw and heard nothing. When the others were asked to rise, I did not know it. When school dismissed I went out in a kind of stupor. (16)

It is problematic when children are not aware of the historical conflicts or achievements that have been documented that pertain to Black culture in the United States. This deliberate omission may be a covering for some form of guilt, hatred, fear of the unknown and / or ignorance on the part of educators that create textbooks for children that omit the historical accomplishments of Black Americans. Educators that skip sections within history books or literary anthologies that limit or exclude the poetry and prose of Blacks around the world do students a terrible disservice. This confirms the statement within James Baldwin's 1963 speech "A Talk to Teachers" that for many still exists today.

> If, for example, one managed to change the curriculum in all the schools so that Negroes learned more about themselves and their real contributions to this culture, you would be liberating not only Negroes, you'd be liberating white people who know nothing about their own history. And the reason is that if you are compelled to lie about one aspect of anybody's history, you must lie about it all. If you have to lie

about my real role here, if you have to pretend that I hoed all that cotton just because I loved you, then you have done something to yourself. You are mad. (329)

Arlene Harris Mitchell and Darwin L. Henderson explain the importance of using Black poetry within classrooms. They emphasize the significance of identifying differences within the culture as well as finding similarities to associate with others. Black children cannot be placed within one exclusive life style, because they vary and so does their literature. "Their experiences will be as varied and as complex as those of their white peers. They are not the "culturally deprived" or "culturally disadvantaged," as some professionals have suggested, but culturally different and culturally enriched" (23). Stereotypes and assumptions are perpetuated through those that refuse to expand the narrow lens of their interpretation of the Black experience.

Critics outside the culture sometimes describe books written by Black authors as being didactic. What is not understood is that these books are a reaffirmation for Black children that they are loved and the didacticism occurs from those outside the culture that read and learn from these books about Black culture. These books are then learning tools for outsiders but within the culture they are the equivalent to weights used for bodybuilding. They can assist in strengthening the mind of a Black child in preparation for the sometimes overwhelming biases taught to them through books that are explained as being of national importance yet spew derogatory words and negative situations that describe this child's culture. Janice E. Hale states that, "The African American cultural tradition teaches African American children the important lessons about the struggle implicit in human affairs. The tendency of Europeans to distort human history has robbed white children of legitimate lessons about overcoming adversity" (151). When history is written distortedly then there is a possibility that it could be strangely repeated. Admitting wrongs and correcting rights instead of omitting them could assist in improving racial attitudes throughout the United States.

By telling their own stories of Black life, these artists teach through their own cultural experiences that are not distorted or morally suspect (contrary to what is sometimes assumed by outside writers). In her essay "Fictions," Jacqueline Woodson states,

> I do not believe someone who is not a person of color can know the roads I and my people have traveled, the depths and heights we reach in our trek from children to young adults. I do not believe anyone who is not of color can step inside our worlds, our skins, our childhoods – and write from there. No, to write Black children's literature, the major criteria is that at some point in your life – you had to have been a black child. (49)

Interpretations of stories about Black children for many years were the only literature that was accepted by publishing companies throughout the United States. These stories written by white authors described how they saw the Black condition whether it was true or not. But in order for the label "Black children's literature" to be valid the author must walk at least a lifetime in the skin of a Black person.

## Living the Blues

The blues aesthetic within Black children's literature has been in place for many years with neither recognition nor understanding of its importance within Black culture. Black children's literature cannot just be classified as an aesthetic literary work but has to be looked upon as a literary vehicle in understanding the historical, political, spiritual, and sociological experiences of being Black in the United States for children. This literature is written by Black writers that assist in creating another set of tracks that link to the crossroads of the blues by shared stories of survival, new myths, and rejuvenated folktales.

Spirituals, blues and jazz are three of the main aesthetic forms that creatively display the Black experience in the United States. Stephen Henderson states that these aesthetics "all energize the idea of Liberation, which is itself liberated from the temporal, the societal, and the political – not with narcotic obsession to remain above the world of struggle and change and death, but with full realization of a return to that world both strengthened and renewed" (27). These artistic expressions of Black folk tradition reflect the pain, victories and struggles of the Black experience in the United States. These three aesthetics along with new ones creatively express the changes within the Black community and lifestyle.

Spirituals - Mind on Jesus
Blues - Mind on Life
Jazz - Mind on the Rhythm

Out of the three aesthetics, the blues aesthetic has had the strongest impact on how the experiences of Blacks in this country are represented. This aesthetic reflects the survival skills used by many emancipated slaves in the United States (Brown, 1952; Jones, 1963; Goines, 1973; Garon, 1975). Arna Bontemps states that the blues is "one of the richest gifts of the Negro to American life" (xiv). The blues aesthetic is the center from which both a spiritual aesthetic and jazz aesthetic can be reached. In *The Blues Aesthetic: Black Culture and Modernism* (1989), Richard J. Powell describes the blues as the foundation of all music:

> Although one could argue that other twentieth century Afro-U.S. musical terms, such as ragtime, jazz, boogie-woogie, gospel, swing, bebop. cool, rhythm and blues, doo-wop, soul, funk, go-go, hip-hop, or rap are just as descriptive as "the blues," what "the blues" has over and above them all is a breadth and mutability that allows it to persist and even thrive through this century. From the anonymous songsters of the late nineteenth century who sang about hard labor and unattainable love, to contemporary rappers blasting the airwaves with percussive and danceable testimonies, the blues is an affecting, evocative presence, which endures in every artistic overture made towards black American peoples. (3)

LeRoi Jones's *Blues People* (1963) historically connected the rhythmic origins of Blacks in America with Africa. Jones believes that the blues can only be associated with Blacks in America and it is the center from which other musical expressions originate even for those evolving social classes that have denied the importance of the blues in order to assimilate to a white American standard (138).

> *Ragtime, dixieland, jazz,* are American terms. When they are mentioned anywhere in the world, they relate to America and an American experience. But the term *blues* relates directly to the Negro, and his personal involvement in America. And even though ragtime, dixieland, and jazz are all dependent upon blues for their existence in any degree of authenticity, the terms themselves relate to a broader reference than blues. *Blues* means a Negro experience, it is the one music the Negro made that could not be transferred into a more general significance than the one the Negro gave it initially. Classic blues differ a great deal from older blues forms in the content of its

lyrics, its musical accompaniment, and in the fact that it was a music that relates directly to the Negro experience. (141)

The blues is American made. It is evidence of the human condition that was created by prejudice and struggle. It is the music of survivors that has evolved into an aesthetic that now tells the tales created the same way.

## Defining the Blues

The blues as a musical form was developed after the Emancipation Proclamation. Strongly connected to the Black laboring class, the blues was the realization that struggle for Blacks in the United States continued whether working as a plantation slave or freely working for oneself. The transition to post-bellum freedom was not easy. Blues music created a way to discuss the ordeals of every day life since legal emancipation did not remove all the problems (Floyd, 73). Instead, new problems emerged such as poverty and stronger forms of racism.

Vocalists, offering a new style of storytelling, sang the blues that told first-hand about the life experiences within Black culture in the U.S. Humorously, sadly, and sometimes sarcastically the singers sang of incidents about how they got over lost love, found love, sex, violence, unemployment and racial discomforts to an audience that could both relate to the singer's situation as well as be entertained by the lyrics and the rhythm (Jones, 1964; Cone, 1991; Floyd, 1995). James Cone explains the difference between the blues and spirituals:

> The blues depict the "secular" dimension of black experience. They are "worldly" songs which tell us about love and sex and about that other "mule kickin' in my stall." They tell us about the "Black Cat's Boned," "a Mojo hand," and "dese backbitin' women's tryin' fo' to steal my man." The blues are about black life and the sheer earth and gut capacity to survive in an extreme situation of oppression. (97)

The blues functioned as the awakening call of freedom for Blacks in the United States after slavery. It was a therapeutic outlet for both the singer and the listener (Goines, 1971). It is an emotional expression of a condition that could not be changed but when expressed, made the singer feel better and the listener feel at ease that they were not alone in their troubles. The blues is not just rhythmically identifiable but it is also emotionally detailed. Leonard

Goines does not just see the blues as being personal but also as a shared form of therapy (31). The blues singer tells the audience that they are not alone in the situation that they are facing because they are survivors of the situation. Singing the song makes them heroes to the audience.

Ralph Ellison's novel, *Invisible Man* (1952), has been described as his literary tribute to the blues. Ellison's own experience, as both musician and jazz critic, along with his strong consciousness of the conditions of Blacks in the 1940's were creatively expressed in *Invisible Man*. Ellison invites the audience into the life of a Black man that tells his blues tale. This anonymous singer stands under the many lights in his basement apartment to unfold his heroic story from boyhood to manhood. This blues epic of a Black man's journey has been used as one of the main reference tools in distinguishing an established literary blues aesthetic (Jones, 1963; Ellison, 1964; Steele, 1976; Powell, 1989; Jones, 1991).

Along with Ellison, other Black writers used the blues as a vehicle to express literary heartaches, social injustices, humorous mishaps, and cultural deprivation. Through their literary work Black writers sang slow rhythmic songs that were consciously humorous and sarcastic in order to display the range of trials, tribulations and victories within Black life.

Romare Bearden's collaboration with blues novelist Albert Murray in the 1970s developed a collection of artwork entitled *Of the Blues* (1975). Murray described the series of nineteen collages as "the visual equivalent of the blues" (Schwartzman, 141). "Bearden's use of torn magazine photos created a modern Black folk art form that could be defined as visual improvisation. Bearden's dedication to the memories of his growing up in both North Carolina and Harlem during the Harlem Renaissance set the mood for his combined tribute to the South and Blacks that he remembered as a child" (151). Bearden's childhood memories designed the visions that made him famous. Remnants of his childhood environment were translated into a visual blues song.

Critics have often taken note of the railroad trains that steam through Bearden's landscapes. These trains, together with the repeated motifs of conjure women, guitar players, women at the bath, and the roosters that watch them bathe, not only suggest the idiomatic particularity of the landscape

Bearden remembers, but also act as metaphors and signposts in the terrain of Bearden's painterly vision (151).

## The Blues Aesthetic within Black Children's Literature

Within Black literature the blues aesthetic has been widely discussed by Ralph Ellison (1953), Houston Baker (1984), Kalamu ya Salaam (1994), LeRoi Jones (Amiri Baraka) (1963), Richard J. Powell (1989), Paul Garon (1975), and Larry Neal (1988) who have all identified through their critical essays various aspects of it. Paul Garon's *Blues and the Poetic Spirit* (1996) includes Black writers that have taken various approaches to interpret the blues. Garon mentions these writers to demonstrate how the blues aesthetic is unlimited to its connections to Black culture.

> But this status report on the blues is far from complete. As one would expect of a music so born of conflict that it would seem at once to be both oppositional and affirmative while exercising ~ at the same time ~ the most exquisite powers of negation, the answers to all our questions are themselves contradictory and conflicted. One reason for this is that through the blues of our times flow several streams, currents not always congenial to each other. (xi)

One stream that hasn't been recognized is Black children's literature. This literature has been excluded in discussions that identify the blues aesthetic even though it contains text and visual art that have the same qualities that can be associated with Black folk art tradition. Black children's literature cannot be placed solely in the world of children's literature because much of it contains strong cultural understandings like that within Black literature. And this literature is overlooked in much of Black "adult" literary venues because it is written for children. So Black children's literature sits between the two yet has the capability to connect to both. It is a bridge builder.

Houston A. Baker's *Blues, Ideology, and Afro-American Literature: A Vernacular Theory* (1984), describes the blues in a way that would seem impossible to exclude the existence of stories written for Black children since so much of what is mentioned describes the literature.

> The blues are a synthesis (albeit one always synthesizing rather than one already hypostatized). Combing work songs, group seculars, field hollers, sacred harmonies,

> proverbial wisdom, folk philosophy, political commentary, ribald humour, elegiac
> lament, and much more, they constitute an amalgam that seems always to have been
> in motion in America – always becoming, shaping, transforming, displacing the
> peculiar experiences of Africans in the New World. (5)

Stepping into the world of Black children's literature is not a small venture but one that is just as large as Black "adult" literature. The voices and topics vary to provide a large spectrum of Black thought.

In his essay, "The Ethos of the Blues," Larry Neal connects the blues aesthetic with folk literature as well as opens up the idea that there are many different audiences that are suited for the blues aesthetic. One probable audience that has been ignored has been the Black child. Neal states,

> An ideal approach to the blues would be that of seeing them as an extensive body of
> folk literature, and therefore subject to all of the laws of folklore. That means where
> we have a variety of primary sources. The blues should be categorized according to
> subject matter (contents), lyric and musical structures, style, region of origin and
> probable audience. (110-111)

Neal recognizes the importance of Black folk literature and perhaps overlooks the existence of Black children's literature but this literature cannot be ignored since it holds, as stated, the same qualities and reasons for the existence of Black folk art tradition.

## The Blues of the Black Child

Black children learn early that the word *black* is quite often used as a negative term, but at the same time this word can describe who they are. Being a Black child in the U.S. has not been an easy task especially since the child is constantly reminded through negative visible signs throughout society that "blackness" is problematic.

We live in a society that places in the mind of every school child the idea that books are important. Dianne Johnson states that "children are not only educated but often are mis-educated through formal educational channels. Children's literature can be a powerful tool of transmission not just of harmless, innocent yarns, but of interpretations of histories and ideologies" (8). The teacher's first exercise when teaching a child how to read is to explain the

value and importance of books in a classroom, and shows how to treat these books in order for them to have a long shelf life (Myers, 1991). When Black children open up the majority of these "important" books that are placed on the school bookshelves they see many important white faces. Black children are visually told through the illustrated pages that little brown, black and beige faces are not as important, except in the month of February, yet, Black children are Black twelve months of the year. The history and stories that are emphasized in February should not be packed away for eleven months, but in many cases they are.

Houston A. Baker explains that the "black blues life" is visible within the context of Black literature. Baker's "black hole" theory identifies the literary condition of Black writers that reflect the darkness of Black life experience even though it is invisible to society. This literature is still recognized because of the energy that is projected by the experiences within the literature that is created through an amalgam of aesthetic events that attracts attention. Black children's literature can identify with Baker's "black hole." It is invisible but at the same time it has been created by many Black writers and illustrators that were pulled into this literary hole by the gravitational energy from the strong need for Black children to have literature that could reflect their own experiences.

There are very few Black literary anthologies that recognize or include the literature that has been written for Black children. So how is it possible to state these anthologies as monumental when they have omitted over one hundred years of literature written for Black children written by former Black children? No wonder Black children's literature has the blues.

## Blues Chapters

The first chapter is divided into two parts. The first part shows the path from which the tracks of Black children's literature began. This historical overview on the establishment of Black children's literature explains why it needs to be acknowledged. It is important to include this history in order to recognize the purpose and the people that helped to establish a literary movement for the benefit of a more positive reflection for Black children toward their culture.

This history pours the foundation for the blues aesthetic found within Black children's literature.

The second half of chapter one will be a breakdown of the three forms of the blues aesthetic: music, literature, and the visual arts. It is important to compare the images that are portrayed in children's picture books with what theorists have recognized in visual art associated with the blues aesthetic. Illustrations are not a part of Black (adult) literature but the artistry of Black artists in this field is not surprising since the visual arts have been imbued with the blues aesthetic for as long as the blues has been in existence. It is imperative in Black children's literary criticism to include visual art theorists since illustrations and texts are equally important for full comprehension of a story. This section provides a narrative that reflects a strong and diverse culture throughout the United States. It can remove images that have portrayed a culture that has been viewed many times oppressively. Dianne Johnson states,

> African American youth live in a society and in a world in which the "happy ending" does not constitute a realistic model. Their realities must be represented, necessity mean "bleak." It means only that the literature must be inclusive of a multitude of experiences. (2)

Johnson along with other scholars and Black children's authors have written extensively about clearer cultural concepts within children's literature. The knowledge and recognition of the blues aesthetic can demonstrate cultural variations while erasing stereotypes that have previously been embedded through various forms within children's literature that have included Black culture but has not been written or illustrated by someone Black. Books that interpret instead of assist in displaying Black culture are many times labeled as user friendly and are accepted more in classrooms because they are not seen as a challenge even when educators are supposed to challenge young readers instead of veiling them with falsehoods that could be detrimental later in their matriculation.

The second chapter defines the blues aesthetic within Black children's literature with a strong emphasis on the blues aesthetic philosophy offered by Kalamu ya Salaam's *What Is Life? Reclaiming the Black Blues Self* (1994) and Richard J. Powell's *The Blues Aesthetic: Black Culture and Modernism* (1989). This chapter, *A Blues Collection*, presents Black writers and illustrators that dis-

play within their stories and images how they value their culture and celebrate the existence of Black children as well as their own Black childhood.

This chapter offers a variety of images that are sometimes invisible to those not acquainted historically to Blacks throughout the United States. It is said to write about what you know and for Black writers and/or illustrators the political, social and economic differences manifest through the words and illustrations on the page.

The third chapter, *Children at the Junction*, connects Black children's literature to the strong representation of the crossroads that Houston A. Baker Jr., LeRoi Jones, Samuel A. Floyd Jr., and Thomas F. Marvin associate with the blues aesthetic. From the images created by John Steptoe, Faith Ringgold, James Ransome and E. B. Lewis, this chapter will bring forth historical, sociological and economical settings that establish insightful tales on the outlook of some already awakened Black children.

The fourth chapter focuses on blues poetry. The work of Langston Hughes is a part of the foundation of Black children's literature. I must agree with Nikki Giovanni: "If you're going to do anything on poetry it ought to start, in all fairness, with Langston Hughes"(154). Hughes did not start his writing career as an adult but as a youth. Hughes began his relationship with blues poetry early and by fifteen years old he was writing poems such as "Dressed Up":

I had ma clothes cleaned
Just like new.
I put 'em on but
I still feels blue.

I bought a new hat,
Sho is fine,
But I wish I had back that
Old gal o' mine.

I got new shoes,-
They don't hurt ma feet,
But I ain't got nobody
For to call me sweet. (27)

Hughes is one of the most renowned poets in the world and much of his poetry can be identified with the blues. Through his autobiography he reveals

that his childhood is not one that is unique but one that many children can relate to. An absent father, a struggling mother and a childhood living in various homes including that of his grandmother who enriched him with Black culture, knowledge, and love. Perhaps Hughes's dedication to poetry and literature for and about children is because he wanted to provide a source of relief, hope and the freedom to dream in a world that sometimes does not lighten up just because you are a child.

Black poets such as Nikki Giovanni, Eloise Greenfield, Nikki Grimes, and Kwame Dawes will be the focus. This chapter will also expand the poetic blues movement by adding the strokes of Tom Feelings. His artistry has accompanied and influenced the words of many Black poets that reflect various blues moods of Black children. It is through these artists that rhythmic verses have been created to reflect the everyday life experiences of Black children. Many times poetry is mistreated once a child has graduated from nursery rhymes. Children still learn the classic poems but many do not know poems by authors of color. This chapter may be able to assist parents and teachers on a variety of poets and poetry children's picture books that are available today.

The conclusion is an overview of why I selected the blues aesthetic within Black children's literature. An awareness of gender, class and color difference begins for some during childhood. Much of Black children's literature does not directly discuss the racial problems that are present in our society, but like the blues, Black children's literature is capable of dealing with life experiences that are reflective in today's society through artistic improvisations that are created by former Black children. This section will explain how this literature gives Black children a comfort zone that allows them the freedom to imagine and enjoy creativity composed of topics that center around images that they can relate to. And these Black artists that contribute to this literature signify through these books the blues aesthetic on how they got ovah.

# Youthful Blues

Sittin' in the classroom, scratching my head,
Sittin' in the classroom, scratching my head,
Trying to understand the book I just read.

For over two centuries, negative images of Blacks and Black culture within children's books existed. During the late 1920s Black parents, librarians and educators realized that these children's books were detrimental tools for both Black and white children and needed to be removed from library shelves. It was time to examine to create new ones that could be more useful as well as truthful.

Some black authors, educators and historians began to realize that for a culture to progress so must the literature that will influence the culture's future. During the New Negro era, Black children were targeted by many of the Negro scholars of that time in order to plant the seed of change within them. In the introduction of *Children's Literature of the Harlem Renaissance* (2004), Katherine Capshaw Smith states "Children's literature played a crucial role in the reinvention of black childhood in the 1920s, 1930s, and 1940s. The major writers of the time were deeply invested in the enterprise of building a black national identity through literary constructions of childhood . . ." (xiii). W.E.B. Du Bois, Jesse Fauset, Carter G. Woodson, Charles Wesley, Mary McLeod Bethune, James Weldon Johnson, Arthur Schomburg, Langston Hughes and so many others during this era knew that the seed of knowledge about Black culture needed to be planted inside the minds of the children.

Black librarians knew that Black children that visited their libraries needed to see images that were reflective of themselves in the books they read, but there were not many such books available. Since this was the era of Jim Crow, Blacks had just been allowed access into some libraries, while other li-

braries (depending on state) still prohibited Blacks entirely or partially from using these facilities. In his essay "The Ethics of Living Jim Crow: An Auto-biographical Sketch," Richard Wright recalls his youthful determination to read by cleverly getting around Jim Crow restrictions to acquire books from the library;

> I was always borrowing books from men on the job. One day I mustered enough courage to ask one of the men to let me get books from the library in his name. Surprisingly, he consented. I cannot help but think that he consented because he was a Roman Catholic and felt a vague sympathy for Negroes, being himself an object of hatred. Armed with a library card, I obtained books in the following manner: I would write a note to the librarian saying: "Please let this nigger boy have the following books." I would then sign it with the white man's name. (13)

The various restrictions applied by libraries across the United States along with the belief that very few Blacks could afford books caused many publishers to believe there was no need to print books specifically for Black readers. Black publishing companies were established but were not large enough to remove the substantial amount of negative depictions from the minds of children and adults.

Augusta Baker, a Black librarian in the Children's Department at the 135th Street Branch of the New York Public Library, noticed the problem of negative images of Black characters in children's books and decided to make a change. In her article, "The Changing Image of the Black in Children's Literature," Baker states,

> By the late thirties, some parents and other adults realized that black boys and girls were reading about the heroes and history of every country without being told the truth about the contributions of their own African and slave ancestors to the progress of this country. They should have been able to read about Crispus Attucks, the Revolutionary War hero; Dr. Charles Drew, whose experiments resulted in the first blood plasma bank; and Phillis Wheatley, the black poet. Never mind the plantation stories! (79)

Baker took the initiative to make a difference and remove from the shelves the books that negatively depicted Black characters as impoverished, lazy, happy laborers still on plantations; characters with largely distorted body features and difficult-to-interpret dialects. This was not the image that Augusta Baker wanted the children visiting her library to process in their minds. According to

Baker, "Children's books seemed to foster prejudice by planting false images in the minds of children" (79). Positive Black images were not possible because very few books portrayed them. White writers were the majority writers of children's picture books and did not perceive Blacks in any other way than submissive. Baker belonged to the era of the *New Negro,* which had been established in the early twenties. This movement brought Blacks into a more openly expressed self-consciousness. Blacks had fought in World War I and the realization that equality should be for all had been embedded in many of their minds. This era brought out Black intellectuals speaking out on their needs; W.E.B. Du Bois, A. Philip Randolph and Marcus Garvey all made their stand on which way this "New Negro" should go for political power.

In 1925, Alain Locke, a professor of philosophy at Howard University, defined this era by presenting a collection of essays, stories, and poetry written by new Black artists that emphasized the cultural aspects of the times. The book was called *The New Negro.* This shifted the term *New Negro* from a political to an artistic emphasis and it became almost synonymous with the term "Harlem Renaissance" (Huggins, 1995, Lewis, 1989). More Blacks were moving up from the South to northern cities with the perception that they would have a better chance of employment and better living conditions. With this migration came new images and new ideas for Blacks, which included erasing the many negative images that were displayed in white children's books. Black children did not need to see these images because they would not raise their self-esteem or motivate them for higher achievement. Baker asked "Is the Negro character a clown or a buffoon whose only object in life is to serve his master faithfully and without question or is he a character who is making some worth-while contribution to the progress of society? There are Negro doctors, lawyers, judges, soldiers, sailors, teachers, in fact Negroes are found in every walk of life" (18). It was time for a literary movement for Black children to take place. The image and progression of the New Negro could not last for long if the next generation was exposed to literature that did not offer positive imagery of their culture.

The authors of children's books were primarily white and not interested in motivating the Black child; on the contrary, they seemed interested in entertaining white audiences by degrading Black culture and using negative Black images as a means of feeling superior. In an interview with Carole A.

Parks in *Ebony Magazine*, Charles Wesley notes, "White publishers were not interested in accepting books by black authors. They thought there was no market for such books and were not interested in points of views held by those authors" (67). The number of juvenile books about minority groups, particularly about the Black child, written before WWI was relatively small, and there was little effort on the part of authors to write stories that would help to tear down the traditional prejudices that were in place at that time. A close examination of the existing stories revealed clearly that many writers based their knowledge of a racial group on their association with a few individuals that needed to be helped rather than to create characters that were independent.

Few Black writers in the 1930s were given the opportunity to publish children's books through mainstream publishing houses. In a 1933 article in the *Wilson Bulletin for Libraries* entitled "The American Negro, A Bibliography for School Libraries" twenty-seven books were suggested "for inclusion in *all* school libraries' four books on the list were written or edited by Blacks (563). The four books included Arthur Fauset's *For Freedom: A Biographical Story of the American Negro* (1927); Arna Bontemps and Langston Hughes' *Popo and Fifina* (1932); Myron T. Pritchard and Mary White Ovington's edited collection, *Upward Path* (1920); and Carter G. Woodson's *African Myths: Together with Proverbs* (1928).

Arna Bontemps and Langston Hughes, both successful writers from the Harlem Renaissance era, collaborated to write *Popo and Fifina* in 1932. This book was about the everyday life of two Haitian children. It was received well and started both writers on the path of many other books written for children. Arna Bontemps continued to dedicate his writing to children with *You Can't Pet a Possum* in 1934, and in 1937 under a grant from the Julius Rosenwald Fund, he wrote *The Sad-Faced Boy*. One of Bontemps most popular books for youth was *The History of the Negro* (1948), which received many awards including the Jane Addams Children's Book Award; it was also a runner-up for the Newbery Award.

Bontemps, being an educator as well as the father of five children, knew the importance of writing books that would reflect positive Black images. He omitted in his books the heavy dialect that supposedly represented the speech of Black people. His purpose in writing children's books was to provide his own children with positive Black characters as well as strengthen their reading

skills. In 1939, a *Horn Book Magazine* article written by Ione Morrison Rider praises Bontemps for his contribution and dedication to the literary world: "Mr. Bontemps, whose own children, Joan and Paul, were beginning to read, continued his interest in children's books. He studied in particular the problem of freeing the natural rhythms of colloquial speech from the tyranny of traditional renderings, that prevent its enjoyment by children"(13). Bontemps took it upon himself, a writer, to create stories not just for his children's enjoyment but also to produce books that would entertain and build up the self = esteem of young Black readers.

In the same year Langston Hughes co-authored *Popo and Fifina*, his poetry collection for children, *Dream Keeper* was also published. He continued to write many poems throughout his literary career for Black children along with many nonfiction books such as *The First Book of Negroes* (1952), *The First Book of Rhythms* (1954), *The First Book of Jazz* (1955), and *Famous Negro Music Makers* (1955).

In order to improve the availability of books for Black children during this time Arthur Schomburg, James Weldon Johnson, and "The James Weldon Johnson Literary Guild" (a Harlem women's book club), worked together to improve the children's section of the 135th Street Branch Library. The group's desire was to acquire material that would be influential to the children and proceeded to make a difference in children's book selection policies. They also gave the library a financial gift dedicated to the purchase of forty books that could meet three specific criteria. Baker states, "It is the purpose of this collection to bring together books for children that give an unbiased, accurate, well rounded picture of Negro life in all parts of the world. Accordingly, these books have been chosen with three points in mind ~ language, theme, and illustration" (131). The most important element in the criteria concerned illustrations that were insulting caricatures of Blacks and inappropriate representations for children to see. Augusta Baker explains that "An artist can portray a Negro child ~ black skin, crinkly hair, and short nose ~ and make him attractive and appealing" (140). This was not a difficult task but one that required a person that cared about the positive imagery of the Black child.

The next important criteria focused on language that covered the problem of dialect. This criterion also included the rejection of derogatory names such as *darkie*, *nigger*, and *pickaninny*. The imbalanced imagery within the literature

and the constant use of dialect showed the blatant evidence of white supremacy. Augusta Baker states,

> There were plantation stories then, with all these children playing together, born and raised on the same plantation. A great deal was made in the beginning of the book of the fact that both the black children and the white children were born on and never left the plantation, and were raised together by "Mammy." Then you'd come to the dialog. The white children would speak as if they had Ph.D's from Oxford, but you couldn't understand one word the little black children were trying to say because you were bogged down in the "deses" and "doses." (141)

The responsibility to change the images of Blacks in children's books was not a concern for publishers, but more so the concern of Blacks that had the power to make a difference in the publishing market.

By the time the forty books were selected for the 135th Street Branch Library, two of the main supporters had died; Arthur Schomburg and James Weldon Johnson both passed away in June of 1938. A year later, the new collection dedicated to the Black children of Harlem was completed and named the *James Weldon Johnson Memorial Collection for Children.* This collection came close to meeting the criteria. Very few books could meet all three requirements in the late 1930s and early 1940s, but the group did the best that they could with the material available.

By 1940, voices were being raised in favor of the production and publishing of books about Black life in-spite of an economic boycott by most Southern booksellers and schools. Organizations such as The Child Study Association and the Bureau for Intercultural Education joined with the NAACP and the Urban League to protest to publishers about the scarcity of good books about Blacks (Baker, 1975). Augusta Baker petitioned publishers and presented them with the criteria so they would know what needed to be seen inside children's picture books. Even after the criteria were established Baker wondered about the acceptance of these books with Black children. "How will black children react to these books; will they want to read more of them; do these books offset the distorted picture of black life in other children's books?" (82). The responsibility now lay upon Black authors and illustrators along with the cooperation of publishing companies to publish books that would entertain Black children positively.

Baker's first bibliography in 1938 established the criteria to share with other librarians so that they could use them to assist young readers in locating books with positive images, language and themes. She soon discovered that there were others outside the 135th Street library that would listen to her and contribute in helping to solve a literary void. "One of my first allies in the fight for better children's books about black life was Frederick Melcher of the R.R. Bowker Company, the donor of the Newbery and Caldecott medals. It was he who literally took me before a gathering of children's editors and told me to "say my piece." Some listened, others resented my presence" (288). Because of Baker's courageous endeavor she was able to get through to enough to convince some publishers to think about the books that were being published for children.

Charlemae Rollins, a Black librarian in charge of the Children's Department at the George C. Hall Branch, Chicago Public Library (1932 to 1963), states the same problem in her article "Promoting Racial Understanding through Books." She also includes her solution:

> In the early forties there were very few books about Negroes for children that anybody could actually recommend or give to them, particularly Negro children, without having them feel embarrassed or insulted. As more and more mediocre books kept pouring off the press into the library and more and more parents came in indignant and more and more children came in and tossed them aside, I felt that something ought to be done. (71)

In 1941, through a writing campaign to various publishers to complain about the lack of books appropriate for Black children, Charlemae Rollins was able to write her first book, *We Build Together: A Reader's Guide to Negro Life and Literature for Elementary and High School Use*. The National Council of Teachers of English responded to Rollins' complaint letter and encouraged her to write about the problem. If she would include a list of appropriate books for the reading pleasure of Black children they would publish her book. Rollins describes the content of the book: "At that time there were only thirty books that we could recommend wholeheartedly without some little explanation and a long list of others that we couldn't" (71). The thirty books that were recommended may have seemed small but it was a tremendous advancement for the Black literary movement. It was significant to have the inclusion of a

list that validated books that were appropriate for Black children to read while a powerful message was also evident in the books omitted.

Several articles were written regarding the progressive move to produce a new image of Blacks in children's books. Some artists believed that it was a progressive gesture for society to see Black characters placed in positive life styles. Critics such as Bette Banner Preer felt that the image should not be the only image that a Black child should be exposed to; after all, children varied. In Preer's article "Guidance in Democratic Living through Juvenile Fiction," she asserts,

> It is not natural, however, for Negro children to want to read only of children of their own race, and those who guide children's reading ~ the teacher, the librarian, in particular ~ should not single out a Negro boy or girl to whom she may recommend a book about a Negro child. Ten to one, that child will not read the book at all, and both he and the teacher or librarian will suffer undue embarrassment. This fact does not hold true for books of history, biography, poetry, and music for people are usually vitally interested in the achievements of their own race, while their desire for knowledge of the achievements of another race springs first from unsatisfied curiosity. (680)

It seemed rather early in the era of these new books to make such a strong statement of what Black children would and would not read but throughout the beginning of the development of Black children's literature it was most difficult to change to new images since many had become accustomed to the old images that were more familiar. Dedication and strong determination by many Blacks brought forth new images that pushed out the negative images, especially in libraries that were largely patronized by Blacks.

In a 1942 study, "Effects of Reading upon Attitudes toward the Negro Race," Evalene P. Jackson proved how important the library was in promoting positive imagery about Blacks. Jackson wanted to prove the social significance of literature as a tool to resolve negative attitudes. Jackson states, "Reading might serve to change this stereotype through its provision of a vicarious experience of Negro life ~ an experience difficult to come by in actual living. This reading should, of course, emphasize the humanity of the Negro rather than the ways in which the white man supposes that he differs from himself" (48). Jackson realized that a study done on measurements of attitudes was beneficial for librarians, since they had the opportunity to assist in removing

stereotypes and prejudice from children. The attitudes were measured by scales designed to determine the degree of their prejudice in favor of or against an object, such as a race or a country. The use of this device made it possible for investigators to measure attitudes toward certain objects before and after the reading of material dealing with those objects and, under properly controlled conditions, to detect the influence of this reading upon them. "Much of the hostility toward the Negro is a result of the failure of the southern white to perceive that the Negro is essentially a creature like himself. The conditions of southern culture give him few opportunities of seeing the Negro in roles other than those conforming to his stereotype of the Negro as a servant" (47). Southern whites perpetuated an image that no longer existed but perhaps was desired since it represented a time in their existence where their living was easy. Bringing forth children's books that included positive images and storylines with Black protagonists meant that new seeds would have an opportunity to be planted into the minds of white southern children.

By the end of the 1940s the majority of public libraries serviced Blacks; publishers had started publishing more children's books written with positive images of Black characters. The Julius Rosenwald Fund put out a free forty-eight page pamphlet entitled *The Negro: a selected list for school and libraries of books by or about the Negro in Africa and America*, to be circulated throughout schools and young people's departments of public libraries. This list consisted of 191 titles, and identified authors as "Negro" or white with symbols beside the authors' names: (W) and (N). The criterion for this compilation was "readability, subject interest, and usefulness in supplying the initial needs for reference material in school libraries" (Lyells, 516). This was a progressive move that benefited schools and libraries that serviced the needs of Black children.

During this early stage of Black children's literature, Black writers such as Shirley Graham, Arna Bontemps and Carter G. Woodson wrote many biographies on famous Black Americans. Publishers seemed to stay away from Black children's fiction perhaps because they were afraid of offending Blacks with negative illustrations or perhaps because of the seriousness of the World War II era. The war showed, according to D. Milender, " . . . the turmoil of the entire country as the newly awakened whites, who had come to know the Negro as a partner in defending their country, returned to communities confused and bewildered. They were confused because they found much of what they

had been taught conflicted with what they had learned first hand by contact with the Negro as a loyal and dedicated defender of his country" (32). This new awakening assisted in getting more Black authors published by mainstream publishers.

In the late fifties many picture books that included Black images were safely done with photographs instead of drawn illustrations for fear by publishers that did not want to insult their readers by depicting Black images stereotypically. The country was slowly changing; the 1954 Supreme Court school desegregation decision helped to make a large difference in the world of Black children's literature. As libraries were forced to open their doors to Black patrons, publishing companies also began to feel the pressure of the Civil Rights Movement. Eventually the fear of fiction lessened and writers such as Lorenz Bell Graham and Jesse Jackson were brought in to write new Black junior novels.

In Lorenz Graham's *South Town* (1958), he was able to convey true to life images of Negro life during an era of change and confusion that was filled with many restrictions because of color. The first encounter young Black protagonist David Williams has with Travis, a white soldier back from Korea, reveals a scene of American history that was new in junior novels and was very rarely discussed. Travis talks to David while walking down the road about his experience in Korea and the Black medics that came to the rescue of many wounded soldiers. Travis described the medics as Black angels with stretchers.

"People are all kinds of fools. I don't suppose I was ever so glad to see anyone in my life as I was to see that colored fellow that helped me in Korea. It makes me mad now when I see colored folks put off in the Jim Crow car and stuff like that" (55). Graham does not romanticize life in the rural South, but tells young readers about the struggle of a Black family that is harassed for standing up to the bigots of the town. In the article "South Town: A Junior Novel of Prejudice," Robert C. Small, Jr. states, "Depicting through their influence on the life of a sixteen-year-old Negro the effects of racial prejudice and conflict, *South Town* combines the ease of reading and simplicity characteristics of the junior novel with a serious and very current social theme and genuine literary excellence" (136). *South Town* was reflective of the time. Set in the South during an era of civil unrest for Blacks, it brought forth emotions

that were surprisingly not sugar coated but more so raw, similar to an open sore for all to see.

*My Dog Rinty*, by Ellen Tarry was published in 1946, and because of its popularity twenty years later it was taken out of *The James Weldon Johnson Memorial Collection* and reprinted. This tale of David, a little Black boy who finds a little lost dog, Rinty, showed the average day of a family living in Harlem. The black and white photographs in a story that does not carry a strong cultural message contains images of a Black family and the community that are solid and free from negative connotations.

In the 1960's monumental changes and advances came when the first children's book that contained a Black protagonist won a Caldecott Medal. *The Snowy Day*, written and illustrated by Ezra Jack Keats, was published in 1962. Because Keats was white there was much controversy regarding the image of his protagonist, Peter. Some described Peter as being just a brown-shaded white boy. This book sparked the fire underneath Black artist John Steptoe, who at the age of sixteen sat down and created the Black children's story *Stevie* (1969). This story depicts the kind of Black images and culture that was missing from Keats' *The Snowy Day* and opened the door for more Black children's books into a new era.

Steptoe's *Stevie* was a historical step in the field of Black children's literature and the value of his first book is evident due to he fact that it is still in print today. Steptoe went on to write and/or illustrate fifteen children's books before his death in 1989.

The Civil Rights Movement brought forth the Black Arts Movement, during the 1960's and 1970's. Black writers were placing strong messages of blackness within their literature. Richard Wright and Ralph Ellison were looked upon as models with *Black Boy* (1945), *Native Son* (1940) and *Invisible Man* (1952) to display their unhappiness about the treatment of Blacks in the United States during the 40's and 50's. New Black writers were picking up their pens as weapons and selecting creative forms to project their unhappiness. A black aesthetic was defined through the literature written by Black writers as well as Black critics. Addison Gayle's *The Black Aesthetic* (1972) was a seminal book of essays that theorized on how to function as Black artists and how this artistic movement could assist in strengthening the Black community. Even though there was no mention of Black children's literature per se,

this movement did not pass by nor escape the notice of Black children's writers. Lucille Clifton, Eloise Greenfield, Sonia Sanchez, Gwendolyn Brooks, Virginia Hamilton and others heard the call, took pen in hand and produced literature that contained messages of Black pride, Black love, and Black struggle.

## The Blues Aesthetic

In *Blues People* (1963), LeRoi Jones conceptualized the history of Black music in relation to the awakening of Blacks who realized they, too, were a part of American culture. Jones contends that blues music has been a base point for all Black music created after slavery (71). Black music is the most progressive aesthetic form in Black culture (Andrews, 1989; Salaam, 1994). And the blues aesthetic has been a strong image within the music (Jones 1963; Keil, 1966).

Blues music is formed by poetic verses set to music, verses sung by singers telling what seemed to be personal experiences reflective of living in the U.S. (Jones, 1964; Baraka, 1987; Rose, 1994; Floyd, 1995). Blues songs covered topics such as love, death, unemployment, travel, loneliness and other social phenomena (Oliver, 1960; Jones, 1963; Keil, 1966; Goines, 1973; Garon, 1975). Jones contends that as the history of Blacks in the United States progressed, so did blues music that moved throughout the South and across the country (105). Blues music has been described as the secular version of spirituals and the root of all other music created in America (Jones, 1964; Murray, 1969; Cone, 1972; Rose, 1994; Floyd, 1995; Dyson, 1996). Jones asserts, "Blues is the national consciousness of jazz ~ its truthfulness in a lie world, its insistence that it is itself, its identification as the life expression of a special people, the African-American nation" (263). The blues aesthetic is a cultural diary that records the methods of endurance and the struggle for identity and citizenship within a country where Blacks have resided for over 300 years and are still not welcomed (Danker, 1973, Steele, 1976, Neal, 1981). Thus the blues aesthetic has been quite an influential artistic form in Black culture. Arna Bontemps states, "Behind these earthly lyrics was the beginning of a new racial consciousness and self conception. It recognized difference but without the usual connotations of disparity. It made no apology, asked no pity, offered

no defense" (xiv). The blues aesthetic stands in front unashamed while explaining the situation. It is not polished like jazz. It is raw. Its beauty is painful.

Most theorists that study the blues aesthetic in literature place in the center of their defense novelists Ralph Ellison and Richard Wright (Jones, 1963; Ellison, 1964; Bone, 1975; Steele, 1976; Tracy, 1983; Powell, 1989; Jones, 1991). Ralph Ellison's *Invisible Man* (1952) tells the fictional story of the life struggles of a Black man from childhood to adulthood during a time in the United States that was filled with tremendous racism. Ellison admittedly describes the novel as a musical literary piece (1964). The narrator is the blues singer that resides in a basement apartment in a room filled with 1359 light bulbs, which is envisioned as a stage (Steele, 1976). This nameless narrator tells a story that many Blacks could have also told during the pre-civil rights movement era.

Richard Wright wrote several novels that fell under the blues with his most known novel being his autobiography *Black Boy* (1945), which begins with his childhood experiences in the South and moves on to manhood. Like Ellison's novel, this novel is set during the Jim Crow era. The image of a Black child growing up in a truly restricted and prejudiced era is presented in both *Invisible Man* and *Black Boy*. Ellison views the inclusion of the blues within Black literature as a survival mechanism helping Blacks endure their circumstances (257). Both novels include episodes that reflect Black childhood, which situates the blues as a Black ageless experience. Ellison compares Wright's *Black Boy* to Bessie Smith's singing of the blues: "There is an almost surreal image of a black boy singing lustily as he probes his own grievous wound" (79). And like most blues songs Wright's *Black Boy* is a tale of his struggles because of racism and of how he got ovah.

Wright's and Ellison's images of the blues reflect a serious and complicated look at the experiences of Black culture. But the prose and poetry of Langston Hughes which contain the blues aesthetic look at the Black experience in a lighter fashion; they can still sting the reader but sooth them at the same time. Hughes emphasizes the lifestyles of Harlemites, moving the blues up North to the big city (Bell, 1973; Redmond, 1976; Klotman, 1978). David Chinitz's article, "Literacy and Authenticity: The Blues Poems of Langston Hughes," reveals that Hughes modeled a lot of his writing after blues music and as the blues changed so did his style of writing. Hughes was the first writer

to write his poetry in the blues form beginning with the use of the rhythm and the classic blues AAB formation (177).

> The blues called my name
> The blues called my name
> Called me out
> And put me to shame

Bruce Dick compares the blues writing of Wright to Hughes and states, "Wright's blues are not great blues. On the whole they are too erudite, elaborate and contrived and so do not measure up to the simplicity and tone of the blues of a poet like Langston Hughes"(405). Hughes brings forth simplicity and humor to present life experiences while holding on to the seriousness of the message (Pickney, 1989; Chinitz, 1996).

Hughes also wrote blues poems for children that were written in the voice of the Black child. Within some of his poetry such as "Merry-Go-Round," this voice is used to emphasize the cruelty of Jim Crow even toward innocent Black children.

Many researchers have realized that the blues aesthetic is forever moving and changing in appearance but at the same time keeping the main elements that can be traced back to it's origin (Baker 1984; Garon, 1975; Powell, 1989). Charles Kiel states, "The blues has always been a migratory music" (60). The great migration of Blacks throughout the United States after the emancipation of slavery set forth an aesthetic journey with the evidence being heard through the music, read in the literature and seen through the visual arts (Powell, 1989; Salaam, 1994).

Many theorists have confirmed that the blues has a strong association with railroad images ~ the sounds of the train whistle, the idea of travel and even the railroad station itself being symbolic to the blues (Baker, 1984; Murray 1964, 1973 & 1974; Garon, 1975). Paul Garon states that this symbolic movement of the blues could be both mental and / or physical (88). Blacks could either be moving out of a state of mind that keeps them oppressed or moving away physically from the oppressor to a better place to live.

> The link between time and space is not lost in the blues. There is a realization that
> what is sought for in space, from South to North, must be sought for in time, from

adulthood to childhood. At first, perhaps, the suspension of movement is our only glimpse ~ after all, why travel if the goal is unattainable? (88)

The traveling image also addresses the life style of the blues singer that moves from place to place to entertain Blacks throughout the country (Jones, 1963; Bone, 1971; Garon, 1975; Floyd, 1995). The blues singer changes and transforms during his / her travels and sometimes includes songs about the experienced encounters in this process. Some of the songs sung by the blues singer in the South were songs to convince the listener to move north. Some songs emphasized the negativity of the South and the splendors of northern living (Griffin, 1995).

Houston Baker defines the blues as a "matrix" that continually establishes new configurations that can still be identified through the unique experiences expressed by Blacks in the United States (5). Baker also uses the railroad metaphor to describe the blues through suggesting that the railway juncture represents the blues and all other aesthetics attach, link and/or cross "over the vastness of hundreds of thousands of American miles"(7). This metaphor of travel suggests that Blacks were the passengers that made decisions to be dropped off in various places holding traits of commonalities while evolving along the way.

## The Art of the Blues

Art historian Cedric Dover states that "A society is a grouping of people: its culture is their way of life. The art of a people accordingly begins when they start thinking as a social group" (44). Ron Karenga expands Dover's thoughts by including art to the concept of a growing society:

> [A]rt is everyday life given more form and color. And what one seeks to do is to use art as a means of educating the people, and being educated by them, so that it is a mutual exchange rather than a one-way communication. Art and people must develop at the same time and for the same reason. It must move with the masses and be moved by the masses. (34)

Dover, like Jones and Karenga, agree that when a people become conscious of their own existence an aesthetic expression will formulate to narrate and represent that culture's experience.

'The Negro artist' did not reach his twenty-first birthday in 1945, nor did 'Negroes enter the main stream of American art' when the United States Information Service decided in 1958 that they had done so. The art of American Negroes has always been a minority art in the main stream of American culture. It is continuity without birthdays. It began when the American Negroes emerged as a group and it will continue as long as they think of themselves as a group, which they will do for generations after they are full partners in their native democracy. (44)

Richard J. Powell lists five concepts that define the blues aesthetic in visual art. In Powell's book of collected blues art forms, *The Blues Aesthetic; Black Culture and Modernism* (1989), an exhibition of various Black visual art forms are present along with literary commentaries on the blues aesthetic within the visual art. This collection defends Baker's blues "matrix" theory through the many interpretations of Black visual mediums along with critical essays that describe various Black art forms that contain the blues aesthetic.

- Art produced in our time
- Creative Expressions that emanate from artists who are empathetic with Afro-American issues and ideals
- Work that identifies with grassroots, popular, and / or American culture
- Art that has an affinity with Afro—U.S. – deserved music and / or rhythms
- Artists and / or artistic statements whose raison d'etre is humanistic. (21-23)

Kalamu ya Salaam's six concepts that define the blues aesthetic as an ethos complement Powell's list. Both lists are useful as checklists in formulating the qualities of the blues aesthetic within Black children's literature, for the literary content as well as the illustrations hold the same value.

- stylization of process.
- the deliberate use of exaggeration to call attention to key qualities, with being one of the most salient projections of exaggeration.
- brutal honesty clothed in metaphorical grace, mass black which included at its core a profound recognition of the economic inequality political racism of america.
- acceptance of the contradictory nature of life - life is both sweet and sour.
- an optimistic faith in the ultimate triumph of justice in the form of karma.
- celebration of the sensual and erotic elements of life, as in "shake it but don't break it!!"(10-14)

The visual images that reflect the blues aesthetic are also from the eyes of Black artists such as Tom Feelings and Faith Ringgold that strongly emphasize visual storytelling that creates and interprets his/her experience. Visual art is another medium to portray the Black experience in America; it looks out to viewers, while viewers look in to search for a familiar form they can relate to (Moore, 1985; Feelings, 1985; Bryan, 1990).

Powell moves his image of the blues aesthetic away from the idea of Blacks as victims within society and moves toward the importance of *style* that is included in Salaam's list. "[I]t is a characteristic that achieves the maximizing of both the community and the individual while avoiding the negation of either" (Salaam, 15). Powell states that "the manner in which black people are represented is a significant artistic statement in and of itself; an indication of lineage, either inherited or adopted"(79). Both Powell and Salaam agree that as the blues aesthetic expands it is more an expression or a formula on how to live and appreciate one's Blackness. Artist Tom Feelings describes the appropriate way in which illustrations are to be expressed within Black children's literature:

> It must move for us ~ up and down like the blues, flowing, flying, flourishing, like jazz. It must pulsate for us like a deep, heavy heartbeat, or glow with the uplifting, luminous energy of our spirituals. Whatever it is it must always *sing for us*. (695)

Critiquing the blues aesthetic within children's literature means analyzing the illustrations as well as the literature in order to comprehend the complete message given to the reader. Many times illustrations have not had equal attention with texts. Donnarae MacCann and Olga Richard state in their book *The Child's First Books* (1973), "Actually the child's eyes, more than the adult's, see the whole of the artist's statement. Untutored, unaware of fashion or fad, the child's eyes take in all that the page offers"(23). The child reads the entire page; text and illustrations are equal. In order for the illustrations to complement the text, both must be appreciated and understood. Powell's list defining the blues aesthetic within visual art and Salaam's list of the characteristics of the blues aesthetic within Black culture make it possible to fully critique the illustrations and texts within Black children's literature.

# A Blues Collection

on the day that i
was born did it begin with
once upon a time?

Black children's literature attempts to eliminate the "peculiar sensation" defined by W.E.B. Du Bois' theory of double-consciousness as "this sense of always looking at one's self through the eyes of others, of measuring one's soul by the tape of a world that looks on in amused contempt and pity" (9). There is no space for pity within Black children's literature, since Black artists are creating this literature to inspire children with books that celebrate survival, honor, respect and love in narratives and visual images. This literature is created by Black artists that deliver messages that counteract the stereotyped texts and images that frequently appear in literature for children. In her article "Something to Shout About" children's author Eloise Greenfield states,

> I want to give children a true knowledge of Black heritage, including both the African and American experiences. The distortions of Black history have been manifold and ceaseless. A true history must be the concern of every black writer. It is necessary for Black children to have a true knowledge of their past and present, in order that they may develop an informed sense of direction for their future. (625)

Blues aesthetic tales for children are many times misunderstood by outsiders to the culture and are seen as depressing, dark, and without *happy-ever-after* endings. Some of Black children's literature that contains the blues aesthetic consists of triumphant lessons of self-esteem that are shared throughout the community and family, displaying a cultural wealth as well as perpetuating a Black style. Janice E. Hale explains in her book *Unbank the Fire* (1994) the

importance for Black children to be exposed to books that include the achievements of Black Americans that have contributed to society. She states, "These stories transmit the message to African American children that, although there are quicksand and land mines on the road to becoming an African American achiever in America, they can overcome these obstacles" (150). Hale continues to state that this literature does not only benefit Black children but white children as well:

> The African American cultural tradition teaches African American children important lessons about the struggle implicit in human affairs. The tendency of European Americans to distort human history and to paint a picture of never-ending European American victories has robbed white children of legitimate lessons about overcoming adversity. The suicide rate among white males, the highest in the country, is an example of what happens when one has been raised in a culture that expects unending triumphs. When one encounters the defeats and frustrations that are a part of living without having a tradition of overcoming adversity, one personalizes defeat. (151)

Whatever literary form the writer uses in these stories, Black children's literature is mainly for the Black child to understand first and foremost. These stories show that Blacks have been progressive in their endeavor to succeed without the assistance of a guide or hero from another culture. These stories have a firm foundation within their own blackness that Virginia Hamilton agrees is needed:

> What being black means is a constant in myself and my work. It is the belief in the importance of past and present Afro-American life to the multi-ethnic fabric of the hopescape and the necessity of making life and literature, the documenting history in schools and libraries for succeeding American generations. It is the imaginative use of language and ideas to illuminate a human condition, so that we are reminded then again to care who these black people are, where they come from, how they dream, how they hunger, *what they want.* (17)

By telling their own stories of Black life, Black writers teach through their own cultural experiences in America, experiences that are not distorted or morally suspect. Joyce A. Joyce states, "the Black artist must look to his unique history and to his people for the ideas and techniques for shaping his art"(73). This literature reflects the beauty of a culture that has the ability to show endurance

and that triumphs through struggles; these stories tell of love and support of community, family, and self.

The six concepts of the blues aesthetic composed by Kalamu ya Salaam attached with Richard J. Powell's visual blues aesthetic concepts along with similar ideas by other Black scholars will demonstrate some of the various forms in which the blues aesthetic is found in Black children's literature. This is not to state that these books mentioned are the only ones that contain the blues aesthetic, but these books are a sample of the various styles Black artists create for Black children.

The rhythm that flows through works such as Alexis De Veaux's *An Enchanted Hair Tale* (1987) and Walter Dean Myers' *Harlem* (1997) are poetic words that play a part in the communal framework of a blues culture. The African proverb "It takes a village to raise a child" can best describe the communal framework within childhood. A support system that expands beyond immediate family that exaggerates yet accentuates the positive imagery for a boy frustrated from the harsh stares he receives because of his dreadlocked hair.

> What a fabric was Sudan's hair,
> what a fan daggle
> of locks and lions and lagoons. (3)

Myers describes sensual elements outside his door that defines that territory that he calls home:

> Jive and Jehovah artists
> Lay out the human canvas
> The mood indigo (11)

These stories are told by writers *not* outside the culture looking in, but within the culture; they are writers that were once Black children. Some of the stories are childhood memories while others are coded messages for inner strength. This literature presents both non-fictional and fictional Black heroes to demonstrate survival and triumph. Some of these heroes are created to address specific problems that may occur for Black children growing up throughout the United States, while other fictional characters are created to assist Black children in discovering that the real hero reflects back to them when they stare

into a mirror. W.E.B. Du Bois states in *Darkwater* (1920), "All our problems center in the child. All our hopes, our dreams are for our children. Has our own life failed? Let its lesson save the children's lives from similar failure" (213). Many of the lessons that could save our children are in these books that unfold stories of the past as well as inspire them to dream far beyond the stars.

## Stylization of Process

Blues talk about human nature and the way people act. They make you cry or make you laugh or simply give you straightforward advice about things we human beings do to each other.

John Cephas (1989, 18)

There is a spontaneous form that is intentionally visible in much of Black literature that is described by Salaam as "synchronization of individual variation within a communal framework"(15). Within much of Black children's literature that contains the blues aesthetic involves a communal presence. Through the rhythm that can be found within various texts, through the imagery placed upon the pages, from the language used to convey the message and the topics, there manifests the stylization of process found within the blues.

The visual imagery on a page accompanied by words create a picture book that can be considered a call and respond format. A good picture book for children consists of illustrations that validate the words and vice versa, creating a much fuller understanding for the child. Through their individual styles of creativity, Black artists are able to present a communal framework based on a core Black culture. Richard J. Powell states,

One aspect of a blues aesthetic which is often misunderstood is the whole idea of style in representation. For some, the manner in which black people are represented is viewed as incidental or as an artifice that gets in the way of "truthful" (re: socioeconomic) representations. For others, the manner in which black people are represented is a significant artistic statement in and of itself; an indication of lineage, either inherited or adopted. (79)

The words to strengthen you are sometimes better received from extended family. Sudan was told by one of his mother's friends, "Sticks and stones

might hurt your bones, but ugly words shall never harm you (De Veaux, 25). Sometimes sight is given to a blind thought through a simple phrase. In Phil Mendez's *The Black Snowman* (1989), the young protagonist Jacob believes that everything black is bad including the burnt pancake in his mother's frying pan. After his mother created a face on the pancake Jacob wondered if the pancake man was happy being black. Jacob's mother gives a simple yet prolific reply: "Happy ain't got no color" (11). Jacob's mother wanted him to know that emotions are not only free but also color blind.

To make the reader feel at home within the story, artistry is based on the language of commonalities and *comfortabilities*. The warmth of words that are not always written but more so spoken within Black culture are formed within black children's literature. In order to provide what Kalamu ya Salaam describes as "a style that employs the collective tastes and simultaneously demonstrates the individual variation on the collective statement" (12) terms of endearment, phrases of encouragement, philosophical verses that bestow homegrown wisdom are placed inside Black children's literature.

John Langston Gwaltney's *Drylongso* (1980) demonstrates the commonalty within Black culture as he examines the stylization of process through his definition of "core black culture":

> Core black culture is more than ad hoc synchronic adaptive survival. Its values, system of logic and worldview are rooted in a lengthy peasant tradition and clandestine theology. It is the notion of sacrifice for kin, the belief in the natural sequence of cause and effect ~ "Don't nothin' go over the devil's back but don't bind him under the belly." It is a classical, restricted notion of the possible. It esteems the deed more than the wish, venerates the "natural man" over the sounding brass of machine technology and has the wit to know that "Everybody talking 'bout Heaven ain't going there." (xxvi)

Stylization of process can be defined through the memory of home that can be found within various stories within Black children's literature. Home serves as a thematic foundation for a number of black writers. Carolyn E. Johnson states in her article "Communion of Spirits,"

> For me in my collective identity as Black America, Home is my attachment, my connection. For a people constantly in detachment ~ either from the biological family or psychological support system ~ the attachment to home is fundamental. Blacks are a collective people, and a collective point, a communion table. (311)

Going home, finding/returning home, remembering/knowing home, and leaving home have all been topics written by Black writers that have created a communal framework of the blues aesthetic. Home is a comfort zone, sweet potato pie, red Kool-Aid, and the quilt you wrap up in that was made by Grandma. Donald Crews narrates through imagery and text memories of his childhood summers spent in the home of his grandparents in *Bigmama's* (1991) and *Shortcut* (1992). *Bigmama's* moves the blues back to the south beginning with a three - day train ride with his mother and siblings. Through Crews' words and images each room in Bigmama's house is remembered along with each area on the farm recalled including the names of each animal.

*Shortcut* integrates the railroad track motif into the continued story of visiting Bigmama, when the children (Crews and his siblings) decide to take a shortcut back to Bigmama's by walking the tracks instead of the streets. An unexpected train frightens them and causes them to jump off the tracks to make way for its quick approach. Crews illustrates each whizzing railroad car that passes with big, bold lettering of the "Klakity-Klak-Klak" in the darkness, emphasizing the closeness of the train to them. The children escaped a close call. They were someplace they were not supposed to be. The secret revealed by Crews as an adult could be a warning about taking shortcuts.

> We walked home without a word.
> We didn't tell Bigmama. We didn't tell Mama.
> We didn't tell anyone. We didn't talk about
> what happened for a very long time.
> And we didn't take the short-cut again. (29)

Once trains were one of the main sources of long distance travel for many Blacks across the United States. The process of returning south by northern Blacks is part of a communal framework that allows variation yet maintains a strong Black tradition. Crews' tale is still a familiar one for many Blacks that make the journey *home* during summer. It reiterates the idea that forms of transportation may change but the tracks all end back at the same juncture within Black culture. The final image in *Bigmama's* depicts the skyscrapers and glowing lights of a bridge in a big city that is shadowed by a self-portrait of Crews. The text reveals that the images of Crews' visits to the South still linger fondly within his memories:

Some nights even
now, I think that
I might wake up in
the morning and be
at Bigmama's with
the whole summer
ahead of me. (1991, 30)

## The Deliberate Use of Exaggeration

Whatever the Negro does of his own volition he embellishes.

Zora Neale Hurston (1935, 227)

A "deliberate use of exaggeration to call attention to key qualities" is part of many children's picture books (Salaam, 15). But in Black children's literature a deliberate use of exaggeration is sometimes needed to get a cultural point across. Humor or an exaggerated reality is created to give emphasis to a cultural link or to disguise issues from others outside the culture. Black folk tradition is often visible in texts and illustrations to amplify cultural beliefs or symbols, and to perhaps create new elements that could possibly evolve into future Black folklore.

The deliberate use of exaggeration is the return to folkloric tradition within. It is expanding the imagination to *what ifs* and *why nots*. Cheryl Hanna and Carole Byard created images to assist in conveying extraordinary tales of blackness. Even without the words the images reveal the spirit of Black folklore.

The reflection of a lion facing the young protagonist, Sudan, in a mirror in *An Enchanted Hair Tale* to represent the pride, courage and strength that the young Black male must obtain in order to deal with people that do not accept his culturally represented hairstyle of dreadlocks. The lion's mane is the original model for dreadlocks. It physically represents one of the most courageous animals upon the earth. Sudan's meeting up with an acrobatic family that calls themselves "Flying Dreadlocks" is not a coincidence but rather a means of strengthening Sudan's self-esteem. This acrobatic group is a communal reassurance that Sudan is not the only wearer of locks. The acrobats carry so much

pride in regards to their appearance that they named their group after their hairstyle. This display of self-esteem is a strengthening mechanism, the use of exaggeration assists Sudan's acceptance to difference. While being entertained by this acrobatic group, Sudan rides upon a zebra that is known as being one of the most difficult animals to tame, symbolic of free flowing hair strands that without the force of comb and brush are able to become dreadlocks. Both the zebra and Sudan's hair prefer to be free and grow naturally without guidance. Salaam's definition of the deliberate use of exaggeration states, "If you don't know the reality, you can't appreciate the joke, precisely because the joke is a comment on the reality"(13). Zebras also represent strength and loyalty to family. According to Jane Ellen Stevens, plains and mountain zebras travel in large multi-family herds and many relationships last a lifetime (2). Hanna's mystical illustrations are a great response to Alexis De Veaux's written call to develop a stronger statement celebrating Black culture.

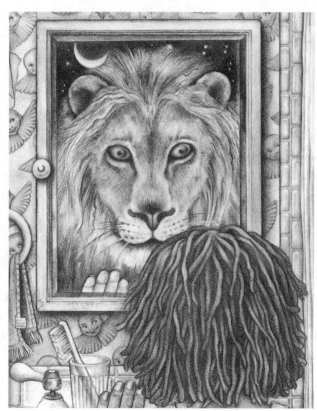

FIGURE 1. From *An Enchanted Hair Tale* © 1987 by Cheryl Hanna. Used by permission of HarperCollins Publishers.

It is this exaggerated element that carries Blacks onward which is similar to blues songs that also establish for many the ability to endure. It is among the tools for survival that are given early for Black children to handle. With literature that tells the stories of their own lives and stories to save the lives of other Black children, writers are taking care of what Asa G. Hilliard calls "family business": "This is the business that the masses of our people ~ children as well as adults ~ do not have a chance to hear. Without these writers, artists, teachers, etc., and others like them, we can never develop any sense of wholeness in a society that sends a constant stream of degrading messages to us" (139). Black children receive negative messages on a daily basis. Very rarely do they see positive images of Black children in the media but instead are associated with negative social elements. The imbalance of justice often views the Black child as guilty until proven innocent. So how is it possible to hear the words *black ball*, *black listed*, *black mail*, and *black market* and not know that the same word that is used to create negative terms is the same word that is used to describe a race and culture? W.E.B. Du Bois did not write *The Souls of Black Folk* (1903) to bring forth the idea of "double consciousness" for Blacks to be pitied; he brought forth the idea as a realization of the situation in order to understand and develop what both cultures could offer.

From the soot of trampling feet on the snow in an inner city, a B/black snowman is made. This B/black snowman (far from being *Frosty*) is both the message and the messenger of the tale *The Black Snowman* (1989) by Phil Mendez. A B/black snowman that comes to life when a piece of kente cloth is wrapped around its neck emphasizes much of what is missing in Black history in schools throughout the United States.

A piece of kente cloth holds its brilliant colors even though it was brought over from Africa more than a century ago. A cloth from a slave ship that appears in an inner city trashcan is taken to decorate a snow creation. This cloth is a potent symbol in a magical tale that hits upon a realistic sore spot in the United States. This cloth brings the snow creation to life and once alive, it begins to conjure up positive blackness for Jacob, a young Black boy that believes the word *black* and himself are both negative. This snowman questions Jacob's logic. He wants to make sure that Jacob is aware of Black strength and not captured in the negative imagery that society spews out on a daily basis.

What is more important in a book - the white pages, the black words, or the message the book holds?

The heavens are black, and the universe is held in it, the snowman said. Should we call the earth bad because it is cradled in blackness? (23)

The B/black snowman inquires about Jacob's knowledge of his ancestry in with which Jacob is unacquainted. Even when powerful visions of African warriors and dancers are conjured up and appear before him, Jacob cannot answer the snowman because he has not been taught about them. Jacob represents many Black children throughout the United States that have not been taught about their history. Malcolm X spoke about the harsh reality of the lack of knowledge among Black children regarding their own history:

> When we send our children to school in this country they learn nothing about us other than that we used to be cotton pickers. Every little child going to school thinks his grandfather was a cotton picker. Why, your grandfather was Nat Turner; your grandfather was Toussaint L'Ouverture; your grandfather was Hannibal. Your grandfather was some of the greatest black people who walked on this earth. It was your grandfather's hands who forged civilization and it was your grandmother's hands who rocked the cradle of civilization. But the textbooks tell our children nothing about the great contributions of Afro-Americans to the growth and development of this country. (44)

Carole Byard's illustrations are in dark colors that assist the message of ignorance. The existence of a positive dark image within this inner city tale sends off a message that no one should be afraid of the dark. This B/black snowman is present to remove the dark emotional state that Jacob is experiencing by informing him of his own worth as well as his African heritage.

Through the writing of Richard J. Powell the artistic work of Carole Byard and Cheryl Hanna can be described as "creative expressions that emanate from artists who are empathetic with Afro-American issues and ideals"(23). The writers and the illustrators' imagination have resulted in tales that demonstrate a form of Black artistic freedom. These stories are imbued with a deliberate use of exaggeration that reflects strength, Black pride and Black selfhood. There is a unique freedom here that comes from the Black imagination.

# Brutal Honesty Clothed in Metaphorical Grace

.The creative imagination sees possibilities which transform natural ugliness into aesthetic beauty.

Carolyn Fowler (1981, vii)

*All Us Come Cross the Water* (1973) tells the story of a Black child that goes in search of his origins. This child holds a positive spirit that has been nurtured in the home and community. This communal spirit is what protects and shields him from a sometimes not so positive learning environment.

In *All Us Come Cross The Water*, Lucille Clifton has included what Ralph Ellison included in his novel *Invisible Man*. Clifton, like Ellison, displays a visible Black protagonist that is sometimes devalued by those within his culture. And also like Ellison, Clifton has made her character not a victim, but an adventurer (Bone, 1966). Ujamaa, the young Black protagonist, has a name that means "familyhood" in Kiswahili. Ujamaa brings forth the double consciousness idea as he confronts his intimate community with a question regarding the origin *of* his ancestry. He has been faced with a brutal geographical question of specific origin, which for many Blacks throughout the United States whose ancestors were slaves the lack of documentation of captured Africans back to the country from which they were taken is an impossible question to answer. Like Ellison's invisible man, Ujamaa had to come up with an answer from within:

> I was looking for myself and asking everyone except myself questions which I, and only I, could answer. It took me a long time and much painful boomeranging of my expectations to achieve a realization everyone else appears to have been born with: That I am nobody but myself. (13)

Within this story a brutal honesty comes forth through the reflection of names. Ujamaa's teacher, Miss Wills, asked the class to state which country their ancestors came from and when she called upon *Jim* to give his answer Ujamaa stayed silent. When her name is lower - cased it describes her attitude toward her own cultural understanding. Her missed wills made Ujamaa unable to respond to her social studies exercise. She mistook Ujamaa's silence for shame instead of him revealing her own ignorance. Ujamaa did not know

what country his people came from. And since Africa is a continent not a country Ujamaa did not participate in the exercise along with the other Black boys in the class because they followed his lead even though they did not understand why. Ujamaa, distraught with his teacher's missed willed question, leaves school on a quest to find out where he is from. Ujamaa's sister, Rose, when her name is lower cased, turns into a verb which means "to rise," which she was doing by attending nursing school, therefore rising above statistics and stereotypes that constantly portray Black youth in degrading images. Even in the illustration John Steptoe has posed Rose leaning on the sink on her tiptoes as she puts on her make-up in front of the mirror. Ujamaa asked his sister where did they come from. Rose tells him where their parents and grandparents are from but this is not the answer that Ujamaa is searching for. Rose believes that before slavery there was nothing else. Disappointed in her answer he moves on to his father, Nat, but also with disappointment because he gives him less information than Rose did; he does advise him to talk with his great grandmother that lives with them. Ujamaa's great-grandmother, Big Mama, was born with a veil over her face. It is said through folklore that those that are born with a "caul" or "veil" over their face have special sight and predict the future (Rich, 1976). She could be part of Du Bois' explanation of double consciousness: "the Negro is a sort of seventh son, born with a veil, and gifted with second sight in this American world, – a world which yields him no true self - consciousness, but only lets him see himself through the revelation of the other world" (9). Ujamaa refuses to be assimilated or ignored because he cannot specifically pinpoint what country he is from. He searches out an answer for himself as well as for his friends so that they are not portrayed as lost boys.

Big Mama tells Ujamaa that her grandmother and mother were brought to the United States from Whydah, Dahomey in 1855. Whydah (Ouidah) was one of the primary slave ports of departure between the seventeenth and nineteenth century slave trade (Law, 1999). Big Mama represents a first generation voice that enables Ujamaa to at least one side of his family tree.

Big Mama asked Ujamaa who he was. He exclaimed his name, knowing that she knew it because she named him. Ujamaa's great grandmother opened his eyes to the reality that the answer he was searching for could be found within. Because of slavery and the many countries in Africa that were affected

by the slave trade, along with the break up of families once Africans were re-located, it was difficult for Ujamaa to discover exactly where he was from. He was a part of many, and so like his name he was the product of unity.

Ujamaa finally resolves his troubles once he goes to talk to his older friend Tweezer. The neighborhood wise man that does not have a name but accepted the name the community gave him tells Ujamaa that his grandfather was cap-tured from Africa how he did not reveal his name. "He figure if they ain't got his name they really ain't got him" (17). Tweezer was like that small tool that is used to extract small particles. He along with Big Mama were able to pick in the young mind of Ujamaa to bring forth the answer that he discovered lay within himself. The next day Miss Wills resumed the discussion. She excused *Jim* from the lesson but Ujamaa was now ready to answer her. "Miss Wills, my name is Ujamaa and that mean Unity and that's where I am from" (26). Uja-maa's origin was not in one place but in many. He was a conglomerate of the people that touched his life and the environment in which he lived. He pos-sessed elements of the past and was saturated with the hopes of the future. Miss Wills' insensitivity and ignorance caused his enlightenment that she probably did not understand yet needed to learn for herself.

Lucille Clifton created a children's story that strongly represented Du Bois' theory of double-consciousness. Rose and Ujamaa's father Nat repre-sented one side of the water – the United States, while Big Mama and Tweezer were aware of their connections to the other side of the water in which they came – Africa. Ujamaa should have felt "his two – ness, ~ an American, a Ne-gro; two souls, two thoughts, two unreconciled strivings; two warring ideals in one dark body, whose dogged strength along keeps it from being torn asun-der" (9). But perhaps for Ujamaa it was difficult to identify his origins at first when warring two souls in a society that constantly wants to assimilate and make you choose one over the other.

## Acceptance of the Contradictory Nature of Life

Of this great mass of dark – skinned children it has been said that they are culturally deprived, yet here is a culture as spontaneous as it is unrecognized. It tells us again that the spirit of man can still endure under whatever misery amd deprivation, on

crowded streets amd in back alleys where the garbage cans overflow, that here there is even laughter and dance and song.

Charlemae Rollins (1968, vii)

Images of Black childhood have many times been perceived and displayed as a place where love seems invisible and emptiness and hopelessness are woven into the story. But this generalization makes for a bad perception that many times is created by writers outside the culture that do not understand that life *is* a bed of roses. They do not comprehend that even if the fragrance and the beauty of the rose are enchanting the thorns are still present to bring forth pain for those that grab carelessly. In his essay "The Creative Process," James Baldwin states, "A society must assume that it is stable, but the artist must know, and he must let us know, that there is nothing stable under heaven" (316). To accept the contradictory nature of life means to be realistic and know that good and evil are both present within a person's life experiences.

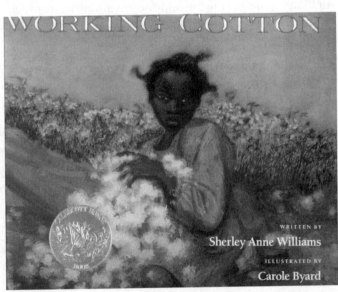

**FIGURE 2. Book Cover from *Working Cotton* by Sherley Anne Williams, illustration copyright © 1992 by Carole Byard, reproduced by permission of Harcourt, Inc.**

Sherley Anne Williams shares her childhood experience with the visual assistance of Carole Byard in *Working Cotton* (1992). The crossroads of the blues aesthetic has many junctures and one set of the tracks takes Black culture West. Williams removes a stereotyped image that has haunted Black culture by unlocking other geographic locations where cotton grows as well as where Blacks reside. Williams describes her childhood home, San Joaquin Valley,

California: "In some ways the Valley serves the rest of California as the Midwest does the rest of the country, as heartland, economically agricultural, morally fundamentalist, staunchly traditionalist. But the Valley is South for a lot of folk in California, too – rural, segregated, laggard as far as changing trends in mainstream culture, which tend to be eastern and urban in origin, are concerned" (816). Williams tells the story of her migrant family working in the cotton fields of California. She poetically narrates a day in the life of a Black migrant family beginning with the cold morning bus ride to the fields and ending with the weighing of cotton sacks, afterwards returning home on the same bus at nightfall. In her article "Returning to the Blues: Esther Phillips and Contemporary Blues Culture," Williams describes through literary blues imagery and sound her early home setting;

> The blues is associated in my mind with the juke joints and muddy roads that were the settings of my early childhood in Central Valley, the San Joaquin Valley of California. It was an essentially rural world that I have come to think of as the other California, so seldom has it been written about or portrayed in anybody's literature. Certain evocations of southern landscapes, Ernest Gaines's cotton fields, Jane Philips's (no relation to Esther) country towns, for example, bring that world to mind as do the wailing guitar, the whining harmonica backing a line of legendary singers, Robert Johnson, Sun House, Muddy Waters, B.B. King, *Dadadada dada, Dadadada dada*, just that opening strain and I can see my oldest sister and her friends, partying to that very music, getting off. (818)

In *Working Cotton*, the image described reflects the unity and love within one Black family. This segment in Black life has not often been portrayed but it has been the experience for many Black families. Artistic director and choreographer Bill T. Jones grew up in a family much like that of Sherley Anne Williams. Jones describes his childhood experience in *Last Night on Earth* (1995):

> My mother, in her old calico print dress, bandanna, baggy men's jeans, and a pair of slides (old shoes with their backs broken down), was always accompanied by a child – in her belly, at her breast, or playing at her feet. When pregnant, she'd walk the rows with a pad in her hand, keeping track of how many bags each picker had filled. At other times, she'd pick potatoes while her newest baby, whichever one of us it was lay in a cardboard box under a tree way down at the end of the field, sucking on a "sugar tit" (lard and sugar wrapped in cotton), until feeding time came.(20)

Jones and Williams were able to share a large piece of sweetness in a situation where others would see it as being very sour. Byard's soft strokes show the swiftness of the father picking the cotton along with the spirit of the mother singing as she picks while watching her youngest children. These were images of a strong sense of optimism and endurance. Life is not perfect even though in many children's books a perfect image of happy children is quite often displayed or a chaotic moment narrates the tale only to be solved by the last page. *Working Cotton* along with many other Black children's books portray real children reflecting a refreshing truthfulness. These books demonstrate children surviving in the real world holding on to love and unity within the family ~ no matter what the situation.

Tony Medina's *DeShawn Days* (2001) is a poetic compilation of DeShawn Williams's consciousness. Medina's first published children's book takes on the voice of a Black male child that most do not realize exist. This new voice is thought provoking, witty, painful but most of all innocent. This child is aware of both the sour and the sweetness of life. Many children throughout the United States are exposed to the harsh realities of life that are not age prejudice. Children are observers as well as victims and from the creative thoughts of Tony Medina and others some of these truths are revealed.

DeShawn lives in an urban neighborhood, aware of his surroundings, happy about the people who love and protect him, conscious of world issues and able to play and dream. DeShawn's voice is similar to Steptoe's Robert and Clifton's Ujamaa. He is not a super child but one with weaknesses from bouts with asthma to childhood nightmares yet he wants to make a difference in the world by involving his class in a letter writing project to connect with children in war torn countries. Medina, a social activist, poet and scholar ,knows of DeShawn's existence probably because he was a DeShawn. Raised in Harlem, Medina was brought up by his grandmother and extended family that supported his creativity.

Medina is able to create "a concoction that epitomizes the concepts of sweet – and – sour contained in one sauce" (Salaam, 57). The sweetness of innocence is seen within the words of DeShawn while living in a realistic environment that sometimes is sour. The reader meets DeShawn's family and his school friends and sadly experiences his grieving over the death of his grandmother.

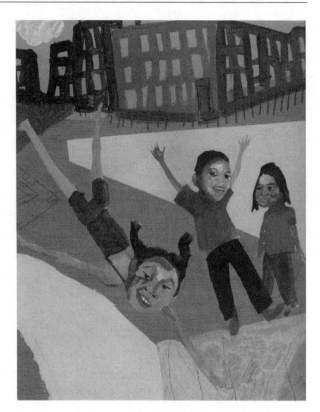

FIGURE 3. From *De-Shawn Days,* © 2001 by R. Gregory Christie, reprinted by permission of Lee and Low Publishers.

R. Gregory Christie's style of painting is similar to that of Jacob Lawrence whose works have been described as "naïve and folk paintings, leading many to regard Lawrence as essentially self-taught, and to describe his work as 'truer' or 'purer' than that of other American fine artists" (Patton, 156). It is through this purer expression that Christie accentuates facial expressions, emphasizes DeShawn's grandmother's elephant legs along with the large hands of the adults in DeShawn's life. Christie's colorful muted illustrations coincide with the voice of DeShawn: they are both rough yet warm, playful yet realistic, harsh yet innocent, serious yet imaginative. The strong facial expressions along with childlike backdrops emphasize DeShawn's life.

Medina's poems combine the joy of Eloise Greenfield's *Honey I Love* and the realism of Nikki Giovanni's "Nikki Rosa" to express the contradictory nature of life that Kalamu ya Salaam describes as "life . . . both sweet and sour" (13 & 14).

My grandma my grandma
she lives in my house

Praying or cooking
with me under the table
listening to the grown-ups
telling stories and the kitchen
is warm and the windows wet
with the smell of cornbread
and baked chicken. (3)

DeShawn Williams lives with his mother, uncle, cousin, aunt and grandmother. The setting of the tale could be in Harlem, Detroit, Chicago or Philadelphia because Medina created a little boy that could be found in all of the cities mentioned and more across the country. He is more common than not but he is less seen in literature and throughout the media perhaps because he is too positive a Black image.

This is a blues narration of a little boy living quite consciously in his urban neighborhood aware of its dangers but celebrates the pleasures of playing with friends and dealing with consequences that life has handed him. DeShawn is not in search of something but is telling the reader what he has found in his ten years of life.

## An Optimistic Faith in the Ultimate Triumph of Justice

[W]hat is wrong will be righted. what is last will be first. balance will be brought back into the world.

Kalamu ya Salaam (1994, 14)

Employment is a strong theme within the blues aesthetic, whether the topic is looking for a job, the loss of a job or working too hard on a job. Emancipated slaves' adjustment to freedom was made more difficut because of the problems of finding employment. Laws established to restrict Blacks from being hired, wage discretions that paid Blacks less than white co-workers, deceiving employers that found reason not to pay, and jobs that were demeaning and deadly were part of the problems faced. This painful realization became reason to sing the blues. The idea of working for more than a hot meal and shelter

was the goal that many set out to achieve. Dreams of owning their own farms, pursuing an education and / or establishing their own business made working harder yet a reason to perservere. In *Uncle Jed's Barbershop* (1993), the optimistic spirit of a hard working Black man with a dream to one day own a barbershop is seen through the narration of Uncle Jed's niece.

Being a Black barber in the South keeps Uncle Jed busy, traveling the country side and cutting the hair of many. The dream of one day being able to stop traveling and to have people travel to his shop was one that Uncle Jed saved his money to achieve. Several times the money was saved to begin his business but obstacles would arise and the money would be lost. But the optimism of Uncle Jed never disappeared. This optimism Salaam describes as being "too deep for the average person to understand just by wondering how any one individual survives" (17). For Uncle Jed, there is faith that "what is wrong will be righted" and because of that balance, Uncle Jed continues to strive for his ultimate goal.

*Uncle Jed's Barbershop* is set during an era of Jim Crow and begins during the Great Depression. This story would appear to express qualities of the blues that Ralph Ellison describes as "an autobiographical chronicle of personal catastrophe expressed lyrically" (79). But this story moves from catastrophe to triumph when Uncle Jed's barbershop finally opens. Even though the barbershop opened shortly before his death, it was still a dream fulfilled by "an unshakable optimistic faith in the ultimate triumph of justice" (17). The triumph comes from the fulfillment of a life long dream.

Ysaye Barnwell, a member of Sweet Honey in the Rock, wrote a song for the group by the name of *No Mirrors in My Nana's House* and in 1998, it was transformed into a picture book, with a colorful visual interpretation by Synthia Saint James. *No Mirrors in My Nana's House* (1998) is narrated by a child raised by her Nana that has showered her with an optimistic viewpoint that was caused by an omission of mirrors within her house. This child was capable through the teachings of her Nana to find beauty throughout her environment as well as in herself. It was only after this child had been instilled with positive foundation that the outside influences came in to expose her to negative ones. She never knew that her skin was so dark yet it seems that it still did not matter because she had been taught the beauty of herself and other things through

her Nana's eyes. In Eloise Greenfield's article "Something to Shout About," she states,

> The media, especially television, for the most part do not reflect the strength of the Black family. The mirror that they hold up for children is a carnival mirror, a funhouse mirror, reflecting misshapen images, exaggerated or devalued as the needs of situation comedy demand. Love is a staple in most Black families. (626)

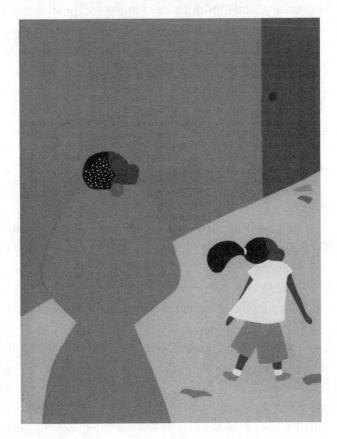

FIGURE 4. From *No Mirrors In My Nana's House* by Ysaye M. Barnswell, illustration copyright © 1998 by Synthia Saint James, reproduced by permission of Harcourt, Inc.

The image of Nana can represent the many Black artists past and present that have enlightened the minds of young Black children with books that contain positive imagery to assist in the building up of their self-esteem and allow them to celebrate their Black culture. Too many times Black children are forced to look into those distorted mirrors that Greenfield wrote about. Mirrors that sometimes create falsehoods that distort the truth on a daily basis. And when

these mirrors are constantly presented in front of a Black child, that child will begin to believe the distortions if there is not something at home or in a book that tells them differently.

Ujaama's distorted mirror came in the form of a teacher that alienated and misinformed him of his cultural origins. This teacher displayed a mirror that was not reflective of the history of Blacks in or out of the United States. Jacob was exposed to the same distorted mirror that omitted the inclusion of his cultural history and literature to cause him to hate himself and his culture.

Falsehoods have sometimes been created in the minds of educators to believe that Black children are not conscious of erased remarks, racist treatments within their classrooms and the omission of literature that reflect Black images. There are sometimes too many distorted mirrors in Teacher's house. Jacqueline Woodson knows first hand; "I am constantly being told that my work, my self, my truths are lesser than someone who is not of color . . . I have witnessed the impact of our society's racism on African American children, have been one of those children myself, have been made to believe I was 'lesser than' simply because of where I came from, the color of my skin, the kink of my hair" (48-49). Black authors and illustrators are part of that optimistic faith that assists Black children to soar over walls of racism that deny them because of their skin color. The books that they create tell these children that it is possible while other books that they are forced in many classrooms to read omit their existence or perpetuate an image of Black culture that is oppressive.

Uncle Jed could have been brought up in a house that had no mirrors. He did not see the distortions but the possibilities. He was a survivor, a trailblazer and a blues man that had optimism too deep for the average person to understand. Uncle Jed was able to survive this struggle because of the faith he held within and the determination to never let go of what he believed in.

## Celebration of the Sensual and Erotic

The freedom to move in space, to demand of my own sweat a perfection that could continually be approached, though never known, waz poem to me, my body & mind ellipsing, probably for the first time in my life.

Ntozake Shange (1976, xv)

Visual images of blackness that have been used by older Black artists have been emulated by young Black artists such as Christopher Myers in *Harlem*, which carries the spirit of Romare Bearden's collage motif. Images of Harlem past and present reflect elements of the blues through everyday living through an art medium of paint, scraps from magazines and used paper products. Both artists metaphorically transform bits and pieces of paper into a collective statement of Black culture, which is seen as an individual interpretation or as a collection of visual riffs improvising the everyday living experiences within Harlem.

One community that was progressively unified by Blacks in the first part of the twentieth century was Harlem, New York. This was the largest Black populated city in the North. The migrations of Blacks moving from the South to the North led many to Harlem. Many Black writers and artists during the 1920s and 30s made this area a Mecca of artistic progression. And thus this era was called the Harlem Renaissance. A spirit of creativity is still felt throughout Harlem today. Through the poetic words of Walter Dean Myers, who knows Harlem as home, and the artistry of his son, Christopher created a visual and textual celebration of the past and the present. This monumental place that laid down sturdy tracks during the early twentieth century, this strong station that housed the blues aesthetic within history ~ this is the place reflected in Myers' poetic words:

> A weary blues that Langston knew
> And Countee sung
> A river of blues where Du Bois waded
> And Baldwin preached. (14)

The collective imagery through collage reveals various aspects of Black culture. This pieced together assemblage includes hydrant showers, hair braiding and pall bearing, while the text speaks of hopes and promises that have led so many Blacks to this place to be called the same as what Walter Dean Myers called it ~ home.

The sensual motion moves over to the words and images in *i live in music* (1994), which expose children to a former resident. Ntozake Shange expresses how she feels about music through interpreting several art pieces by Romare Bearden. Shange explains that "I got 15 trumpets where other women have

hips" in order for others to know that her entire body is dedicated to melodic sounds. The selected pieces by Romare Bearden celebrate Black music as well as the community that make up Harlem interact vibrantly with Shange's poetic confession of her love of music. Bearden compared his creative impulse to the blues when stating, "You must become a blues singer ~ only you sing on canvas. You improvise ~ you find the rhythm and catch it good and structure it as you go along ~ then the song is you" (31). This duet of words and vision demonstrates their individual ability to improvise as well as harmonize their appreciation for visual and musical poetics.

*i live in music* explains Shange's feeling of being enveloped with music, and how the music physically becomes a part of her, while Bearden's collages illustrate the creators of the sound and the people, like Shange, that love it.

> sound
> falls round me like rain on other folks
> saxophones wet my face
> cold as winter in st. louis
> hot like peppers i rub on my lips
> thinkin they waz lilies (30)

Ntozake Shange's sensual confession makes it capable for readers to imagine that music is touchable. She includes readers by first asking them, "do you live in music?" and then proceeds to tell where she lives(c# street) as well as where her friend lives (bb avenue), letting the reader know that she is not unusual; other people live in music also. She makes abstract elements concrete by using similes that can be readily understood.

Bearden adds the images of others, who like Shange live in music. His creativity through torn magazines creates a variety of sensual images that connect with Shange's words. Bearden began utilizing collage medium in the early 1960's and describes his works in the same way Salaam describes the process of style: "I paint out of the tradition of the blues, of call and recall. You start a theme and you call and recall" (31). Black children's literature can be compared to the artistry of Romaire Bearden. The sensual images and words are gathered together by artists that recall pieces of memory and fabrics from their imaginative thoughts that called to them requesting to be combined and placed on paper to create stories for Black children. This sensual nature is not

sexually associated but more so connected to a child's imagination; a mental playground where they are allowed to run free. This sensuality like Ntozake Shange's words connects to the freedom within their minds, which we call imagination.

Child readers can be seen as blues children just like the ones characterized within this chapter. Ujamaa is an example of a survivor, as are DeShawn and Sudan, all of whom find strength through the love of community, family and themselves.

The poets and illustrators have placed themselves upon the pages, expressing their love sensually as well as humorously and poignantly. The blues is a celebration of conditions that are present, and memories that are past. It is in the rhythm of Ntozake Shange telling where she lives, and in the poetic evocation of a once ~ treasured home in Walter Dean Myers', *Harlem*.

Many of these stories do not contain pat endings with an "all is well" resolution. Instead, a story is a little spoonful of good that sits on the same plate with the bad. And whether it is a ride on a train, walking the train tracks, witnessing your parents picking cotton, or conversing with family members, answers are ultimately found by looking inside oneself. These stories leave the reader with hope and wonder, but they are brutally honest about what may happen after the last page.

Messages to Black children that need reassurance take the form of showing that the child is not alone; if DeShawn, Sherley Anne Williams, Donald Crews, Sudan and Ujamaa can "make it" there is an optimistic faith that others can make it too. These stories are therapeutic just like the blues. And they can be used as bibliotherapy for children who are searching for the kinds of answers that can only be discovered by looking within oneself.

The blues is an artistic measurement that evolves in order to travel through an ever-changing culture yet comes back to the same spot once done. Ntozake Shange explains in a metaphorical grace her love of music while a young girl explains how her firm foundation was created through her Nana's eyes. Albert Murray states that "Art is by definition a process of stylization, and what it stylizes is experience"(54). These are artistic styles that are just like Black culture; they are not alike yet they express Black experience.

# Children at the Junction

Misery is when the teacher asked you who was the father of our country and you said,
"Booker T. Washington."

<div align="right">Langston Hughes (1967)</div>

S hadow & Substance (1982) was a study by Rudine Sims, who surveyed 150 works of contemporary fiction that were written about Blacks and published between 1965 and 1979. This survey revealed that out of the 104 authors who wrote the books, only 34 were Black writers who "produced books of the culturally conscious/self-affirming type"(104). Sims sought to expose the importance of culturally conscious fiction for Black children and the development of literature that "presents an image of Afro-Americans as courageous survivors with a strong sense of community and cultural affinity and with positive feelings about being Black" (105). She wanted to bring forth the positive effort that was successfully achieved by authors and illustrators that knew the importance of positive imagery as well as pushing forward the criteria created almost fifty years before that insisted upon themes that showed Black people self sufficient, family oriented and conscious of improving their community.

Self-identity is important for children to possess. When Black children do not see their life experiences within the literature that they read, or do not see an image on a page that is physically similar to their own, then their self-esteem can be lowered. To emphasize one culture and ignore another does not help any of the children involved. While false walls of status are being built, children are being deprived of a balanced educational environment.

Many Black writers and illustrators realized the need to build up a better self-concept for Black children by creating literature that included the every day experiences of Blacks throughout the United States. Julius Lester believed that writing for Black children would hopefully give them the strength and

pride that had deliberately been kept from them (72). Tom Feelings states "Books as much as anything else for children in this country have to take in the reality of all the children's lives in the present as well as in the past – for the children of today do affect the future" (693). This literature can be therapeutic for Black children that do not see their image often enough in a positive setting.

Leonard Goines' article "The Blues As Black Therapy" is comprised of a random selection from a 30-year span of 270 blues songs that he analyzed and placed within 10 subject categories. Gaines' study revealed that blues music could have a therapeutic effect on Blacks. Blues songs have been a way for Blacks to face their problems and release their anxieties for "once you name it, you can claim it, then it's possible for you to tame it!"

> The blues are used by the Black man as a vehicle for emotional release at times when he feels himself helpless and incapable of effecting a resolution for the emotions and/or problems faced. It is for this reason that blues celebrating the pleasures and happiness of love are few. Further, the blues is a means of portraying the Black man's relationship to his society and times. They illustrate the types of situations, events and feelings which give rise to the need to create, sing or listen to the blues. (40)

Goines analyzed the lyrics that were reflective of the experiences of Blacks. Songs created from Blacks' awareness of the negative images that some whites held of them; songs of love (lost or found); songs of unemployment, travels, and other life situations. For Blacks to sing about their life situations, whether good or bad, while other Blacks listened and related to the problems, thus becoming a therapeutic experience for both (31). Albert Murray defends Goines' study with the quip, "We invented the blues; Europeans invented psychoanalysis. You invent what you need"(72). For Black people the need to express their experiences developed into an aesthetic that assisted in their survival. Their blues experiences didn't have to originate from a childhood drama but from a current situation. One does what is necessary to survive.

The selection of the three Black writers that will be the focus in this chapter is based on their blues styles and their monumental contribution to the field of Black children's literature. Each brings forth a unique way in which to convey reflective messages about being Black in the United States.

John Steptoe entered into the field of Black children's literature closer to the end of the Civil Rights Movement. At a young age he saw an omission in

children's literature and developed through his illustrated stories a young Black voice that spoke *for* Black children, *about* Black children, and *to* Black children. Steptoe did not tiptoe around issues; he faced them whether mole-hill or mountain. He exposed them through the voice of a Black child.

Faith Ringgold is in a field where very few Black women are both writer and illustrator. She follows in the spirit of Steptoe by presenting social issues that are mostly read about in school textbooks, but seldom seen creatively in children's picture books. The magnificent artistry of Ringgold preceded her entrance into the world of children's literature. To have that same quality of art now dedicated to children is truly an educational breakthrough. *Tar Beach* (1991) is a monumental work that exemplifies Black art tradition through the artist's medium as well as through the imaginary spirit of the artist's story.

A strong contributor to young adult literature, Jacqueline Woodson has in the past few years written several children's books that are as controversial as her YA novels. As the world changes so must the topics in children's litera-ture. Gwendolyn Brooks states, "Remember that ART is refining and evoca-tive translation of the materials of the world!" (11). Some topics are difficult to discuss and cannot be sugar coated but through the artistry of Woodson's words and imagery by E.B. Lewis and James Ransome, the sour is brought through sweetly. Virginia Hamilton states, "Change is what we learn is real. And the real is always changing" (374). Jacqueline Woodson is a real writer.

## Owning the Image on the Page

Where do Black writers place their blues when writing Black children's literature? They place it at a level that Black children can understand because these writers remember what it was like to be a Black child. Writer / illustrator Ashley Bryan states,

> This is where childhood is the root. Childhood is, at every moment, universal to all the living. One is always in it or of it. Adolescence, adulthood, old age may not be granted the child. But the adolescent, the adult, the elder bears a childhood in common with the child. (298)

At sixteen, a young Black artist named John Steptoe wrote and illustrated his first children's book, *Stevie,* that was published three years later in 1969. This

story was told through a new voice, one that had not yet been heard in the publishing world, but was desperately needed ~ i.e., the voice of the Black child. Steptoe wrote *Stevie* in order for Black children to identify with subject matters, language, and life settings that would be somewhat familiar to them ~ something that he did not see present in other literature for children.

Steptoe used his creativity to fill a literary void for Black children. He knew through his own growing up that Black children needed picture books that could aesthetically express stories that would be more familiar to them. He wanted to replace the books that had been written by whites that included Black characters. He was aware of how these stories were not able to tap inside the spirit that was built upon the struggles of Blacks past and present. Publishers preferred to have a Black story told by a white writer than to hire a Black writer. The Black experience could not be mimicked by observing or assuming. It had to be experienced. Novelist Julian Mayfield explains the problem with imitators: "For deep in their guts they cannot feel what we have felt. Their eyes cannot see what our eyes have seen, and what the eyes of all those generations of dead and dying old black men and women saw, from slave ships to cotton fields to ghetto obsolescence; the crushing of manhood spirit in childhood, the destruction of what was pure and beautiful and godlike in ourselves before we could see it" (31). Perhaps publishers at that time were afraid of the real voice that spewed out the truth but what they were discovering through that fear was that these books that interpreted were being rejected by Black readers young and old.

In the August 29, 1969 issue of *Life*, three illustrations and the complete text of *Stevie* were printed along with an article in praise about the young John Steptoe. Within that article Steptoe introduced himself to the world.

> I have been taught Western ideas of what a painter is, what painting is, and that stifles me because I am not a Western man. I have never felt I was a citizen of the U.S.A. ~ this country doesn't speak to me. To be a black man in this society means finding out who I am. So I have got to stay on my own, get out from under induced values and discover who I am at the base. (59)

Steptoe brings forth the blues aesthetic through the voice of Robert, the young storyteller, explaining his life without the flowery or happy ever after attitude. *Stevie*, narrated by Robert, a young Black boy reminiscing about his time spent

with Stevie, a younger boy that stayed throughout the week at Robert's home because Stevie's parents' worked late hours. Robert was not used to sharing his belongings nor being responsible for anyone but himself. At first Robert looked at Stevie as an intruder in his home, but eventually accepted him. A blues atmosphere flows through while Robert takes center stage to sing the "Stevie Blues." Phillis R. Klotman's article, "Langston Hughes's Jess B. Semple and the Blues," correlates with Steptoe's portrayal of Robert's "loneliness blues." This loneliness occurs when "there is no one to quarrel with" (76). Robert begins his story at the beginning while singing another type of blues:

> Sometimes people get on your nerves and they don't mean it or nothin' but they just bother you. Why I gotta put up with him? My momma only had one kid. I used to have a lot of fun before old stupid came to live with us. (26)

By the end of the story Robert has reconsidered his feelings for Stevie, while recalling the fun he had with him, and at the same time realizing that he is now alone with just memories.

> So then they left. The next mornin' I got up to watch cartoons and I fixed two bowls of corn flakes. Then I just remembered that Stevie wasn't here.
> Sometimes we had a lot of fun runnin' in and out of the house. Well, I guess my bed will stay clean from now on. But that wasn't so bad. He couldn't help it cause he was stupid. (28)

Steptoe creates two stanzas to Robert's "Stevie Blues," the first being the trouble that was created by Stevie's entrance into Robert's life and disrupting it. The second stanza is about missing Stevie and feeling alone now that he has moved away. Stevie enters Robert's life almost as quickly as he is taken away. Steptoe uses Robert to sing about the life styles of two Black working class families through the eyes of the child. Stevie was placed in the care of others while his parents worked (perhaps overtime) in order for the family to move on. Neither family was oppressed nor expressed anger about being Black in the United States; instead this story illustrated what Herbert Kohl would call "working people with dignity, [who] present an image of collective and compassionate living, and dramatize common struggles to create a decent life" (79). *Stevie* is an example of communal support.

The blues is known for its transience, for its evocation of Blacks moving throughout the United States after Emancipation (Garon, 1996). Stevie's par-

ents had to work some overtime to have enough financially to move on. They were putting down new tracks for their family. Houston A. Baker Jr. uses the image of railroad crossings for his interpretation of the blues. "Polymorphous and multidirectional, scene of arrivals and departures, place betwixt and between (ever *entre les deux*), the juncture is the way station of the blues" (Baker, 7). This juncture that is crossed constantly continues to adapt to the new experiences of Blacks throughout the country.

Steptoe crossed the blues juncture and connected a new track by placing the Black child as the blues singer, singing to an audience of Black children. These youngsters were now able to hear songs sung personally to them, songs they could identify with. This very young writer stepped out into the darkness to a "black hole" whose gravitational pull attracted his artistic talents and reached an audience that was filled with energy but had been completely invisible to much of the American eye. The literary field had not been well equipped to step into this "black hole" before Steptoe, since many writers did not have the correct cosmic attractions. "Like translators of written texts, blues and its sundry performers offer interpretations of the experiencing of experience" (Baker, 7). John Steptoe was able to bring forth a new performer to the blues stage that was young, energetic and also knew the blues.

This continuously changing experience for Black is reflective in the character, Stevie, a young boy who is placed into another home throughout the week in order for his parents to work. Stevie was the transient individual, and at the same time the juncture that connected everyone in the story. In Sterling Brown's essay "The Blues as Folk Poetry," the relationship of the blues with the passion that Blacks have for traveling is explained as a form of post-Emancipation freedom (381). "These lovers of the open road, in their desire for the far country, turn to the train as their best friend" (379). It was a vehicle of wonder that represented freedom. They were free to go wherever they wanted to on this train that linked the county together with tracks that were blind yet upon them rode segregated compartments and even with this segregation the travel was still brought them all to the station at the same time.

John Steptoe's book *Birthday* (1972) is the story about a little eight-year old boy, Javaka, who is having a birthday. It and his home are special. Javaka was the first child born in the village of Yoruba. This village was developed by a group of Blacks that no longer accepted the mistreatment of Blacks in the

United States so they moved away to create their own independent community. It is at the end of Claude Brown's introduction in *Manchild in the Promised Land* (1965) where he asks, "For where does one run to when he's already in the promised land?" (xiii). John Steptoe answers that question through this historical fiction written for children.

The blues juncture crossed over and moved onto a new track that left the United States. The blues that were created by American experiences are now scars that exist in the memories of Blacks that have taken flight. James Baldwin stated, "I left America because I doubted my ability to survive the fury of the color problem here" (171). The pain that was created is understood better through a quote from Kofi Anyidoho's *AncestralLogic & CaribbeanBlues* (1993): "And yet must I take with me memories of those who put some meaning to my nightmare" (xiii).

> My Daddy always tells me about the time before we came here to live and the old America, where him and my Mamma used to live at. He says the people there didn't treat him like a man 'cause he was Black. That seemed stupid to me 'cause my Daddy is the strongest and smartest man alive.
>
> Him and his friends couldn't live there no more 'cause if he didn't fight to leave, his life wouldn't be no good. When I grow up, I'm gonna be strong like my Daddy. (4)

Yoruba is a modern day maroon community. Maroon communities were established when enslaved Africans revolted from their oppressors violently and ran to the hills to escape the cruelties of enslavement (Hilliard, 1988; Sunshine, 1988; Hood, 1990; Fox, 1995). Steptoe's Yoruba community left "Old America" to avoid violence, and like the historical maroon communities they too were tired of being oppressed and left to obtain their freedom, create cultural continuity and preserve human dignity. Steptoe fills more of the black hole with particles that cannot be seen but have a strong gravitational pull. In the history of the United States two Black communities at different times detached themselves. In 1967, approximately 350 Blacks from Chicago were discontent with the treatment of Blacks, left the United States and moved to Africa. This group of people led by Ben Ammi Ben-Israel became the largest group of Black Americans to reside outside of the United States today. These Black Americans have lived for over thirty years in Israel and are now called the African Hebrew Israelites.

In 1972, a religious movement of Blacks from New York, led by His Royal Highness Oba Oseijeman, moved to South Carolina. Oseijeman purchased land and established Oyontunji, the only African village in the United States. In Oyuntunji, thirty people reside today and continue their Yoruba religious traditions that are practiced throughout the African Diaspora and originated in West Africa (Lefever, 180).

These real movements were compelled by the struggle for Black liberation during the sixties and both movements are historical omissions within most American history. Black movements that were strong enough to detach themselves culturally, physically and/or spiritually are very rarely mentioned. The idea that Javaka lives in a Yoruba village shows that Steptoe created much more than what the critics understood. Benjamin C. Ray explains in *African Religion: Symbol, Ritual and Community* (1976) that beliefs within Yoruba religion are shown through the traditions and ceremonies: "[people] symbolically relive their history in the recognition that the past continues to define and legitimate the present political order"(45). Javaka's birthday is important to celebrate because within a Yoruba community it is part of the "cycle of Continuous Creation" as well as a sign of good fortune to a village to have children (Ray, 1976; Teish, 1994). Ron Karenga states, "All material is mute until the artist gives it a message, and that message must be a message of revolution"(33). Claude Brown's question is answered by Steptoe's revolutionary message inside *Birthday* that liberation can be fulfilled in many ways and one way is to leave the oppressed environment and begin again somewhere else. His story was easy enough to understand for Blacks who knew the history of the Civil Rights movement, as well as those who could relate to the idea of living in a community free of restrictions due to skin color.

The juncture forever stretches to demonstrate changes within Black culture and Black literature. Bringing forth the idea of liberation within Black children's literature moves toward what Kalamu ya Salaam categorizes as "brutal honesty clothed in metaphorical grace," from his central elements of the blues (13). Also Herbert Kohl recognizes stories that include the "existence of an enemy who has abused power," as well as a story that "illustrates comradeship as well as friendship and love"(67). These stories bring forth new worlds and new ways of living united.

John Steptoe brought the Black child into view by placing his characters in neighborhoods along with other Black children and created Black communities that worked together and held the same family values. This child was able to possess a loving family and all this could be done without displaying oppression, grinding poverty or the stereotypes that had previously been visible in children's books about Blacks. John Steptoe proved that Black cultural experiences could be displayed aesthetically without being depressing or demeaning. Black culture offered every reason to celebrate.

## Making Somethin' out of Nothin'

Putting together pieces of life to create beauty, to pass down tradition and to emulate history is what quilt making is all about. Houston A. Baker Jr. and Charlotte Pierce-Baker warmly describe this tradition in their article "Patches: Quilts and Community in Alice Walker's 'Everyday Use'": "A patchwork quilt, laboriously and affectionately crafted from bits of worn overalls, shredded uniforms, tattered petticoats, and outgrown dresses which stands as a signal instance of a patterned wholeness in the African diaspora" (706). In my family, quilts are defined as *making somethin' out of nothin'*. Quilting is a form of recycling. There is no such thing as throwing a shirt or dress away just because it is ripped or faded and can't be passed down for someone else to wear; instead these items can once more become useful by including them in a quilt.

In the field of Black children's literature there are many Black women writers but very few that are also illustrators. Faith Ringgold puts together stories that are framed by colorful pieces of Black childhood memories and sewn together with threads of complexity as well as love. In her children's picture book, *Tar Beach* (1991), she gathers together many elements of Black folk art tradition. Ringgold uses the art form of quilting to visibly format her story. She is renowned for her artistic expression through narrative quilts. By combining a tradition of Black female quilt making with her strong Black political consciousness, she is able to display warmth and love into a story that can be understood by both children and adults.

Many Black women writers have placed within their literary creations the idea of a quilt, either physically in the story or mentally through fragments of ideas that form a literary culturally authentic quilt (Kelly, 1994: Bell-Scott, 1991). Faith Ringgold has been able to do both; she has quilted a literary imagery upon a visual quilt to make a unique book. The quilt has been an important art form for Black women since American slavery. Houston A. Baker, Jr. and Charlotte Pierce-Baker state, "The transmutation of quilting, a European, feminine tradition, into a black women's folk art, represents an innovative fusion of African cloth manufactured, piecing, and applique with awesome New World experiences -- and expediencies"(706). A form of making somethin' simple into somethin' better can also make it something more meaningful.

Many times during the era of slavery, slave women would piece together with the mistress of the plantation a very "rigidly patterned" quilt during the day and at night go into their own quarters to create story quilts as a form of recording family history, life experiences and spiritual beliefs (Fry, 1990). Valerie Lee states in *Granny, Midwives & Black Women Writers* (1996) that "Black women are also knowledgeable recorders of their history and experiences and have a stake in faithfully telling their own stories"(36). Ringgold demonstrates this tradition by putting together a story quilt to tell the history and experiences of the Lightfoot family.

Black folklore is the filling to Ringgold's story quilt that depicts a flying child. This transcendent image is implicitly connected to the flying African myth that has been recounted by Langston Hughes and Arna Bontemps (1959), Richard A. Dorson (1967), Julius Lester (1969), Virginia Hamilton (1985), and Janice Liddell (1994), as well as Toni Morrison in *Song of Solomon* (1977).

The Georgia Writers' Project in 1940 conducted field interviews with slave descendants from the Georgia coastal region. Superstitions, remedies, and stories that were used by slaves and orally passed down were recorded and compiled by the workers of the project to create *Drums and Shadows* (1940). Through interviews many tales of folklore were told, but one of the most common was the witnessing of the African slave that had been so overwhelmed with the brutality of slavery that he took flight from the plantation never to be seen again. Not seen as a narrated myth or a folktale by the people

being interviewed, but recounted as a true event witnessed by one of their family members this story continues to be a strong part of Black culture and is constantly passed on. The question remains pending as to its mythical or factual basis.

FIGURE 5. From *Tar Beach* by Faith Ringgold, copyright © 1991 by Faith Ringgold. Used by permission of Crown Publishers, an imprint of Random House Children's Books, a division of Random House, Inc.

Prominent images of flying are found within Black literature that represents a mental and / or physical freedom (Jones, 1991; Mobley, 1991). Cassie Louise Lightfoot, the eight-year-old narrator of *Tar Beach* uses this freedom to tell her story:

> I can fly - yes fly. Me, Cassie Louise Lightfoot, only eight years old and in the third grade, and I can fly. That means I am free to go wherever I want for the rest of my life. (10)

In *Should We Burned Babar?*, Herbert Kohl explains why it is important for children to use their imagination like Cassie in *Tar Beach*: "[T]he imagination is the power to go beyond experience and, in the mind, to break or change the rules of all the games we are forced to play, whether they are imposed by other

people, genetics, or the natural world. It is a source of new rules as well, of thinking the as-yet-unthought-of as we experiment with the development of felt values" (65). Cassie's imagination leads her to flight, which has been seen as empowerment and freedom. By flying over the new union building her father will be able to seek employment without prejudice. Flying over the ice cream factory represents perhaps in a young child's mind financial wealth and her opportunity to have dessert every night. And to Cassie her "most prized possession" was the George Washington Bridge. The bridge was special to Cassie because her father worked on it during its construction and it opened on the same day that she was born. Cassie's imagination assisting in resolving her family's problem: "Well, daddy is going to own that building, 'cause I'm gonna fly over it and give it to him. Then it won't matter that he's not in their old union, or whether he's colored or a half-breed Indian, like they say" (13). Cassie's freedom appears through her imaginative resolution to her father's racial obstruction. She could have imagined for some mechanism that would have turned her family white but instead she, like the youthful W.E.B. Du Bois, flies above and beyond the barrier to possess all that causes their restrictions.

Through fantasy the blues can be humorous in reaching a solution. Kalamu ya Salaam defines humor as "nothing but an exaggeration of reality in order to make a point"(13). Problems or situations that occur within the blues are sometimes solved through imaginative means similar to the song sung by Peg Leg Howell.

> If I had wings like
> Noah's turtle dove
> If I had wings like
> Noah's turtle dove
> If I had wings like
> Noah's turtle dove
> I would rise and fly and
> Light on the one I love. (1928)

The blues sometimes uses folklore as a coding mechanism. Paul Garon admits that blues songs sometimes work as both a form of entertainment and a way for Blacks to signify their race-related troubles without alerting white audiences (197). Cassie sings the *no union blues* that produces a socially

conscious atmosphere that alludes to a situation that was a common problem in the 1930's for Blacks. Within the framework established in Leonard Goines' study, *Tar Beach* would be categorized under "Songs About Work And Its Problems"(31). Paul Garon might have seen *Tar Beach* as "the product of black creativity and genius forged under the pressure of racism"(197). It is through the eyes of a child that Faith Ringgold presents an imaginative tale that is consciously aware of the issues of racism that do not hinder Black love in a family but just allows the mind to soar a little higher.

In *Double Stitch: Black Women Write About Mothers & Daughters* (1991), the theme that flows throughout the book concerns the beauty of the quilt and how the relationship of mothers and daughters is evoked by the term *double stitch*; "This term describes a strengthening and decorative technique symbolic of the bonding between mothers and daughters. Just as the double stitch stabilizes and embellishes a fragile design, the mother-daughter tie lays the groundwork upon which subsequent relationships are built and elaborated" (1). Cassie is aware of her mother's pain because she sees her tears when Mr. Lightfoot does not get work nor return home at night. The quilt symbolizes what Margot Anne Kelley suggests in "Sister's Choices": "the promise of creating unity among disparate elements, of establishing connections in the midst of fragmentations"(56). In *African-American Art* (1998), Sharon Patton states, "For her the quilt, so intimately connected with women's lives, seemed the most effective vehicle for telling a woman's life story" (242). Cassie connects with her mother through their love for her father and each other. She knows that if her father has stable employment, everyone in the family will be happy. Daphne Duval Harrison explains in *Black Pearls: Blues Queens of the 1920s*, how female blues singers had to sometimes, like Cassie, escape their surrounding oppression through singing songs that "reorganized reality through surrealistic fantasies and cynical parodies. . ." (64). Cassie is aware that her father has difficulty getting work because he is not white, even though he is good at his job. And it is through the power of her imagination she resolves her father's problem by owning the one thing that is holding her father back ~ the new union building.

The blues woman, whose song is true to her own experience and rooted in the values and beliefs of the community, empowers those that love her and effects change in those around her. Her outer struggles and inner conflicts

reflect issues of oppression in society as they have been internalized within the community. In *Salvation; Black People and Love* (2001), bell hooks describes the type of strength Cassie's mother had in order to keep the family together:

> Our mothers, unlike their white counterparts, had to try and make a home in the midst of a racist world that had already sealed our fate, an unequal world waiting to tell us we were inferior, not smart enough, unworthy of love. Against this backdrop where blackness was not loved, our mothers had the task of making a home. As angels in the house they had to create a domestic world where resistance to racism was as much a part of the fabric of daily life as making beds and cooking meals. (35)

Initially, Faith Ringgold did not intend for *Tar Beach* to be a children's story; she used the voice of a child not for children to hear but for adults (25). Ringgold placed many of her own childhood memories about living in Harlem within *Tar Beach*. The love and fascination of the George Washington Bridge originates from her own childhood. "Ringgold likes the way bridges are formed because they remind her of quilts floating in the air. She sees their triangles as being little quilt patches of air separated by the girders" (Turner, 25). The idea of "the beach" derived from Ringgold's family outings upon the top of their apartment building. "Children got to stay up late if they promised to lie quietly on a mattress"(9). Ringgold created a double quilt by forming an entire story literally upon a quilt as well as piecing together fragments from her own life to place within this story to bring it to life. This story uses quilted pieces of the blues. It is filled with images from folklore and backed with the solid cloth of family love and survival. *Tar Beach* is both socially and aesthetically balanced as it portrays elements of Black culture through an instrument that represents Black economic struggle as well as historical insight (Brown, 1989; Fry, 1991; Baker & Baker, 1985). The racial issue that is brought out in *Tar Beach* is heard through the voice of a child who was aware of the complexity of being Black during an era of Jim Crow laws.

Like Steptoe, Ringgold tells a story without a "happy ever after" ending, but a story, utilizing the memories of a child to celebrate survival as well as cultural pride. The blues ideology manifests itself through both storyline (pertaining to Cassie's father's employment) and the images of flight as a means of problem solving through Cassie's imagination. All you need is somewhere to go that you can't get to any other way.

## Old Tracks, New Blues

Many Black children's books are created around family. Jacqueline Woodson presents two old family topics, *Visiting Day* (2002) and *Coming on Home Soon* (2004), that are rarely discussed but have been a part of many families. For some the topic in *Visiting Day* would be labeled a family secret even though to a child that is a part of such a family this book could be an assurance that they are not alone. The latter book, *Coming on Home Soon*, unfolds an historical misconception that was publicized to commemorate the heroic acts of white women that stepped up to save the country during World War II. Both books created by Woodson reveal truths that enable children to open up a dialogue within their families while many Black female elders can proudly reminisce about their own heroism.

Figure 6. From *Visiting Day* by Jacqueline Woodson, illustration by James Ransome, © 1997 by James Ransome. Reprinted by permission of Scholastic Inc.

A young girl narrates the routine that she and her grandmother go through to prepare for their visit to see her incarcerated father. This is a new concept in children's literature yet an old one in the blues aesthetic. Preparing for a journey that is not by train but another blues vehicle; a bus and packing up the food for the bus trip and having enough to share is all a part of the communal framework of the ride with others on their way to do the same. James Ransome's familiar imagery shows family photos throughout the home while in the father's quarters crayon drawings from his daughter are posted on his jail cell wall. The images complement the storyline enough to be allowed to speak on wordless pages that quietly allow the reader to witness the narrator and her grandmother stepping onto the bus.

The grandmother has placed a peace within her granddaughter that enables her to be patient and know that her life will not always be like this.

> Grandma says all it takes is time
> a little time,
> and while we're holding out waiting
> for Daddy to come home
> we can count our blessings. . . (27)

Children sometimes believe that they are not worthy when they do not see similarities of their lives in picture books even though according to the Bureau of Justice Statistics in 1999 there were 721,500 incarcerated parents to 1,498,800 children under the age of 18 (Mumola, 1). There are very few children's picture books that discuss an incarcerated parent, yet facts show that many children throughout the United States have one. Jacqueline Woodson and James Ransome create a brightly illustrated story that is "brutal honesty clothed in metaphorical grace" (Salaam, 13). This young protagonist is not telling a story of her difficulties but one that details the highlights of her life – a visit to see her father. In 1997, only 21% of male inmates received monthly contact with their children (2). This little girl's visitation is a harsh reality for some but for others a reality just the same. This book can be seen as controversial or labeled stereotypical because it is a Black father that is incarcerated. Painful as it seems this is the reality for many children and since no one is telling this story, even children that are not Black can read *Visiting*

*Day* and relate to it if they are in the same situation. For many children this book is a tool needed to soothe their young souls.

Woodson's creativity and thought provoking message keeps up with a world that is forever changing. She writes stories that detail today's issues while also bringing out new insight in historical fiction that reveals a truth that has been overlooked too long. In her essay "Fictions" Woodson explains the position of her writing:

> I wish I had the privilege to just sit and write without bringing the facts of life into my work. That as a woman who is African American, my whole world is political so of course my writing is. That I would love to live one day of my life free of thoughts about the mechanics of our system of things. But I can't. and because I can't be writing in which a reader can escape their own struggles and have a good read. On the contrary. It becomes writing where a reader recognizes a part of themselves and because of this, knows that they are not alone in the world. Writing where the reader's life is legitimized and by extension, the reader is legitimized. (48)

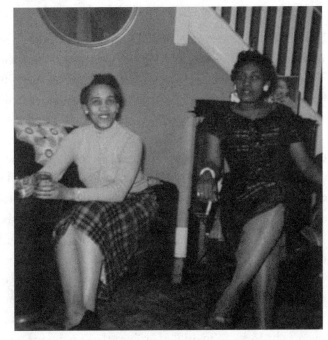

FIGURE 7. My aunt, Estella Bradley and my grandmother, Grace Wofford, both Rosie Riveters. Photo circa early 1950s.

During World War II, my grandmother and aunt worked in a Detroit factory making airplanes. Women filled 96,000 positions within the major war industries throughout Detroit and Black women filled only 1000 of these

positions (Anderson, 85). My grandmother was given a custodial position in the woman's bathroom handing out towels while my aunt worked out in the plant putting parts on airplanes. It is not clear the reason for my grandmother and aunt's placement but it is believed that because my grandmother was dark and my aunt was very light so she was assigned the *better* job. Now 91 years old, my aunt still remembers the hard work and the frequent unkind words spewed at her. WW II changed the work force throughout the United States. Because of the high quantity of men at war, job vacancies had to be filled by women. This economic event pushed many walls of Jim Crow down in order to keep the U.S. military operational. In *When and Where I Enter: The Impact of Black Women on Race and Sex in America*, Paula Giddings explains the employment hierarchy during this era:

> Women were working in the naval yards, weapons factories, communication equipment lines. The image of a smiling Rosie the Riveter was etched into the American consciousness. But the great employment wave withered to a trickle when it came to Black workers in general and Black women in particular. (234)

Black women are very rarely seen in any of the vintage newsreels that detail the dedication of the American people that assisted in the war efforts during WWII. *Coming on Home Soon* is a tribute to the many unsung heroines that fought a racial battle for equality in the work place in order to assist in the war efforts overseas. In the essay "Last Hired, First Fired: Black Women Workers during World War II," Karen Tucker Anderson states, "Although scholars have given some attention to the labor – force fortunes of blacks in the war economy, few have considered the impact of the wartime expansion on black women, who constituted 600,000 of the 1,000,000 blacks who entered paid employment during the war years" (82). Ada Ruth, the young narrator in *Coming On Home Soon*, feels the emptiness along with the pride of her mother's employment during the war. The blues aesthetic returns to the tracks where Ada Ruth's mother is now working in Chicago and it is "On the railroads minority group women found employment in substantial numbers as laborers, loaders, car cleaners, and waitresses" (Anderson, 88). Woodson has given sight to these invisible heroines that pitched in during a time when the United States needed their services, yet they were represented by a symbol that clearly white washed their contributions.

E.B. Lewis' watercolor illustrations of snow-covered land sets a tone of emptiness while his images inside their home set a tone of warmth, love and patience. Standing inside looking out a frosty snowy window a little girl and her grandmother wait patiently for letters from Chicago. On the page across from that image is a small oval image of Ada Ruth's mother standing in front of a train with a snow shovel in her hand. Lewis gives the reader a glimpse of what a Black Rosie the Riveter could have looked like.

> In Chicago, Mama said, I can wash the railroad cars.
> Just imagine, Ada Ruth, A colored woman working on the railroad! (16)

Imagine.

There are signposts that many passengers on a blues train might not recognize. These signposts are there at stations that travel across and connect the blues crossroads. These signs mark tracks that do not take a rider off the route, but provide the passengers with a much more colorful landscape. When riders on this blues train look out, they are amazed because the faces they see are those of Black children that are living and loving naturally. They are not like the stereotypical characters from the past depicted as forlorn, needing to be saved (generally by someone white), ignorant, and poor. These children freely express themselves through literary topics that are old yet new. The three authors discussed in this chapter have brought forth social and historical issues that reveal new points of view within old topics attached to Black "adult" literature.

John Steptoe provided a generation of children with a realistic voice that even on a moving train the riders are capable of hearing. This new track that is connected to the blues juncture makes it possible for Black children to tell their own stories in terms that are comfortable and realistic. Steptoe saw a void and filled it himself without hesitation. Sharon Bell Mathis states in the 1972 essay "Who Speaks for a Culture":

> If you have no books to give blacks that are written by blacks, tell them about 18 – year old black and beautiful John Steptoe. And if you're for real, they'll get your message. John Steptoe didn't wait. He began to write and illustrate his own books. Believe in two facts: Black kids are intelligent. And we are a beautiful people. (33)

Faith Ringgold provided new imagery for little girls when she gave them the opportunity to fly across the sky through the gift of imagination. They owe this freedom to a Black folk tradition that exposes historical, social and economical issues creativity onto a story quilt. Ringgold does not make this quilt to show a path to freedom but instead her quilt displays how free Blacks have traveled when on the path to equality.

Jacqueline Woodson steps up with two books that bring forth topics that have been placed in the dark for one reason or another. Releasing the truth can be such a relief and for others a historical enlightenment. Woodson admits, "There has been some backlash against my truths" (1995, 713). But like the saying goes "The truth shall set you free," Woodson's freedom with words enables many children to free their minds with the peace that they are not alone. She also states " But I want to leave a sign of having been here. The rest of my life is committed to changing the way the world thinks, one reader at a time" (715). This station is not new nor is the train that takes passengers to this area. It has always been in existence and many people travel the route. Perhaps with the help of this book more will notice the area in order for a larger signpost to be hung.

# Blues Poetry

Misery is when you start to play a game and someone begins to count out "Eenie, meenie, minie, mo . . ."

Langston Hughes (1969, 25).

If I cud ever write a poem as beautiful
as u, little 2/yr/old/brotha,
poetry wud go out of bixness.

Sonia Sanchez (1971, 18)

The first exposure to poetry for many Black children comes in the form of street rhymes: *Shake it to the one that you love the best, Miss Mary Mack, My momma told me* and *Miss Lucy.* These are a few that popularized the front of my house, as well as many school playgrounds across the country. I found it quite wonderful to see and hear the same street rhymes being performed by my two daughters when they were young. Kyra D. Gaunt's book, *The Games Black Girls Play: Learning the Ropes from Double – Dutch to Hip – Hop*(2006), reflects the commonality of street rhymes that are performed by Black girls throughout the country. Gaunt states,

> Studies of handclapping games, cheers, and double – dutch have documented African American play in major urban cities in the Northeast (Philadelphia, D.C., and New York City) in the South (Texas and Alabama), and in the West (Los Angeles). Black girls as young as three and as old as fourteen practice these games, which dominated urban play as easily as the 1960s. By 2001, the games black girls play turned up just about anywhere American children are present or represented. (56)

Street rhythms that are sung, danced, and clapped are part of an oral tradition. They are learned quickly and remembered for a lifetime. If poetry were taught in the classroom with the same energy and spirit of street rhymes, more children would probably be attentive when it is taught in class.

In Black poetry, the poet places a rhythm with the words that is sometimes overlooked when placed in books or recited by readers who have not developed the beat. It is sometimes seen as a difficult venture to translate a Black poem from paper to voice. Stephen Henderson comments on the importance of knowing the structural content of Black poetry; "Structurally speaking, . . . whenever Black poetry is most distinctly and effectively Black, it derives its form from two basic sources, Black speech and Black music. It follows, then, if this is correct, that any serious appreciation or understanding of it must rest upon a deep and sympathetic knowledge of Black music and Black speech and ~ let us be plain ~ the Black people who make the music and who make the speech" (31).

Charlemae Rollins states in the foreword of *I Am the Darker Brother*, "Prose can expand and explain, but poetry must be felt" (1968, viii). I have always thought of Black poets as musicians that use words like instruments. They get their paper in hand, a beat within their head and create what Larry Neal would probably refer to as "scores." The musician hands the score to the band, but not without first demonstrating how it is to be performed, which is the recitation of the work by the poet. Poetry is a verbal and visual art form that sometimes gets lost when handed over to those who have not first studied the background components of the piece or the "musician" – the Black poet.

The first poem that I ever memorized (besides nursery and street rhymes) was Paul Laurence Dunbar's "In the Morning." My aunt would recite this poem with such sass, that I learned most of the poem through her recitation and was inspired to learn the rest on my own. I wanted to know it well enough to recite it with the same spirit as she did. This humorous poem that recounts the morning ritual of a mother wakening her son and getting him to the breakfast table was not dialectically familiar to my own household but the activities within the poem were.

> Bet ef I come cross dis flo'
> You won' fin no time to sno'.
> Daylight all a-shinin' in
> Wile you sleep-w'y hit's a sin!

In grade school, I learned many poems but the one that I was most fond of was Robert Frost's "Stopping by Woods on a Snowy Evening." I fell in love

with the rhythm and the imagery of the words and the soft detailed moment of admiration by a traveler that sees the beauty of the snow coated forest. My fondness for this poem may derive from the memory of how beautiful my teacher recited the poem when she introduced it to the class.

> The woods are lovely, dark, and deep,
> But I have promises to keep,
> And miles to go before I sleep,
> And miles to go before I sleep.

In junior high, I was introduced to a variety of Black literature. I was introduced to many works by Black poets as well as learned about the lives including that of Paul Laurence Dunbar. I enjoyed the rhythm of Gwendolyn Brooks' "We Real Cool" and cried reading Dudley Randall's "Ballad of Birmingham" that focused on a young Black girl's request to her mother to attend a freedom march rather than to attend church. Her mother refuses because she feels it would not be a safe place for her daughter and makes her go to church instead. But this is 1963, Birmingham, Alabama and a bomb goes off inside the church that the mother thought was sacred and safe. She runs in search of her daughter through the rubble.

> "O, here's the shoe my baby wore,
> but, baby, where are you?" (144).

One of the poets taught that was introduced to me in class moved on with me to high school as well as to college and has remained constant in my life was Langston Hughes. I learned many of his poems in and out of classrooms. The first of his poems that was introduced to my junior high school class to be memorized was "The Negro Speaks of Rivers."

> I've known rivers:
> Ancient, dusky rivers.
> My soul has grown deep like the rivers.

This is one of Langston Hughes' most renowned poems. Hughes wrote this poem at the age of eighteen. This free style poem that traces the existence of Blacks back to the beginning, alludes to three African rivers and then flows on to the pains of Blacks sold up the Mississippi River was written by an unhappy teenager on a journey. "The one of my poems that has perhaps been most

often reprinted in anthologies, was written on the train during this trip to Mexico when I was feeling very bad. It's called 'The Negro Speaks of Rivers' and was written just outside St. Louis, as the train rolled toward Texas" (54). Hughes was pained about his journey to visit his father knowing how much his father disliked being Black. Hughes looked at being Black as a wonderful and proud experience. His father's self-hatred bothered him: "I didn't understand it, because I was a Negro and I liked Negroes very much" (54). James Hughes had moved to Mexico soon after Langston's birth, leaving mother and child behind in the states, because he wanted to be treated like a man without racial barriers. Once Langston completed high school his father sent for him and while sitting unhappily on a train looking down at the Mississippi River, this eighteen-year-old youth was inspired to write down the ideas forming in his head, "My soul grows deep like the rivers." Arnold Rampersand explains that the poem " . . . has nothing to do with race; it is dominated by images of the poet not as a teenager but as a little child" (695). Poet Eugene Redmond explains the importance of Hughes's words:

> The use of words like "soul" and "rivers" ~ which run like spines through black folklore and literature, allows Hughes to touch the deepest longings and spiritual wellsprings of his people. In "veins," "deep," "flow," "dusky," "ancient," and the cataloging of actual place names important to Blacks, he establishes the longevity of life and struggle. (192).

Hughes states in his autobiography *The Big Sea* (1940), "For my best poems were all written when I felt the worst. When I was happy, I didn't write anything" (54). He placed his pain within his writing as a form of therapy, and even as a child he knew how to express his pain creatively. Langston Hughes knew the blues at an early age. He is known for staying in touch with his people by developing in many of his poems what Eugene Redmond describes as "a dialogue between the black underdog and the white ruler"(193). Hughes distinctly states throughout his writings how he felt at ease, relieved, and happy when he was surrounded by "folks with practically no family tree at all, folks who draw no color line between mulattos and deep dark-browns, folks who work hard for a living with their hands" (208). Hughes wrote about the absurdity of "the best colored society" and on several occasions was excluded

from this group during his younger life. Hughes explains the complications of being a social poet:

> So goes the life of a social poet. I am sure none of these things would ever have happened to me had I limited the subject matter of my poems to roses and moonlight. But, unfortunately, I was born poor – and colored – and almost all the prettiest roses I have seen have been in rich white people's yards – not in mine. That is why I cannot write exclusively about roses and moonlight – for sometimes in the moonlight my brothers see a fiery cross and a circle of Klansmen's hoods. Sometimes in the moonlight a dark body swings from a lynching tree – but for his funeral there are no roses. (212)

Young Hughes traveled from household to household, living the longest amount of his childhood with his grandmother in Lawrence, Kansas. His grandmother earned money by renting out rooms in her house; this was to take care of food and to maintain the mortgage on the house. Sometimes it would be necessary for them to move out of the house so it could be completely rented out. Hughes' grandmother filled his childhood days with stories of triumphs from the *Bible* and about heroic Blacks and whites that fought against slavery (Rampersand, 1985; Hughes, 1940). His childhood was enriched with his grandmother's love and the everyday experiences of survival.

Measuring wealth monetarily or denying the fact that a famous Black person was raised in a low-income environment are instances of either dissembling or romanticizing. Some outsiders that look inside Black childhood experiences find it difficult to interpret. Nikki Giovanni states, "Your childhood was good because you survived it, whatever else, no matter what condition you're in, you've survived it" (156). Langston Hughes survived his childhood but for some outside his culture his childhood has been misinterpreted. Giovanni's poem "Nikki Rosa" emphasizes how outsiders sometimes misunderstand the culture, the race or the class environment of Black childhood. Sometimes it is the color that blinds them to similarities and makes them more insightful to the differences that can be either good or bad.

> and I really hope no white person ever has cause
> to write about me
> because they never understand
> Black love is Black wealth and they'll
> probably talk about my hard childhood

and never understand that
all the while I was quite happy (154-155)

Blues poetry captures lifestyles, experiences and emotions. So often blues is thought of as expressing just hard times but it also exists to laugh at oneself or a circumstance, and to accept the life that has been dealt. Paul Garon specifies that the blues distinguishes itself from other aesthetic forms "by its predilection for first-person presentation" (9). The blues is self-centered. It is a solo act. Children are also self-centered because of their continuous physical and mental growth and discovery. They are a solo act. In his essay "Blues as Black Poetry," Stephen Henderson states "for the overreaching theme of our literature is Liberation or Freedom; even when statements are personal" (25). Through Henderson's definition it is obvious how Black children's literature reflects his theory. Children are straightforward in their thinking and freely express themselves without hesitation.

## Feeling the Poetry through Imagery

My only regret about living in a visual era is that when the pictures no longer match our faces we feel excluded. In an oral age we drew our own pictures in our own minds and everyone looked liked us.

Nikki Giovanni (2001, 107).

Because I did not see faces that were similar in color to my own children often enough inside the covers of children's picture books I entered the field of children's literature. As a Black mother I thought that it was important to raise my children with a fair balance in their literature. I wanted them to be mentally and physically strong and in order to do that I had to make sure that they were exposed to books that spoke of their own values. So I sought out books that celebrated Black culture and that told my children that they were not alone when their environment said just the opposite. I sought out these books so much that I decided to enter graduate school in order to learn about the history of Black children's literature and study closely the people that created it.

*I Saw Your Face* (2005) is a testimony for me that all that I studied while getting my Masters and PhD was not in vain. This book is a dedication to my

children and the many beautiful brown children around the world that sometimes feel that they are alone because in many of the books that they see the faces inside don't look like them. This celebration of African Diasporic children has universality through the images created by Tom Feelings and the words composed by poet Kwame Dawes. The book smoothly transports the reader to a somber, peaceful place that when the journey is complete makes the reader want to say "ah" while closing the book and wondering who needs to be the next reader.

My eleven years in the field of children's literature has allowed me to become familiar with the artistry of many Black illustrators such as John Steptoe, Jerry Pinkney, Ashley Bryan, George Ford, Javaka Steptoe, R. Gregory Christie, Faith Ringgold, Christopher Myers, Brian Collier and so many more. But it is the work of Tom Feelings that initiated my study of the blues aesthetic. Tom Feelings' drawings of Black children have been able to place the blues aesthetic visually upon the pages of *I Saw Your Face*, Eloise Greenfield's *Daydreamers* (1981) and Nikki Grimes' *Something On My Mind* (1978). And unlike most illustrators, Feelings' portraits of Black children were first and then the invitation to the writer poet followed. Feelings' work does not tell stories but releases emotions or better yet feelings. His artistry captures the spirit of each child that appears upon the page. The strong Black features, with semi-smiles and far away glances, complement the rhythmic words of Dawes, Greenfield and Grimes to create books that reflect the beauty of Black children. Or is it the other way around?

Feelings' collection of portraits was produced over a twenty-year period and his desire was to magnify the beauty of Black children in order to celebrate their existence. His use of two main colors in *Daydreamers* as well as in *Something on My Mind* was to "show both joy and sorrow" because both books have an American setting (694). The idea of reflecting double consciousness in his drawings was his purpose, in order for Black children to know both their past and their present - in order for them to deal with their future. Feelings states in his essay "The Artist at Work: Technique and the Artist's Vision,"

> There is a definite bittersweet duality going on in the best Black work ~ a mutuality of consciousness, for those two major elements of our lives, joy and sorrow, never just exist side by side, on a flat surface. They interact with each other and build on each other; the sorrow and pain of the Black experience have always been tempered by the

strength of Black people, and our joy has been tempered by our pain. Always surrounded by restrictions and limitations in terms of form, we are hostage to hope, we improvise in spite of those restrictions, sometimes transcending the form itself, making it new. We celebrate life, we can take the pain, we have endured it. (695)

I have not yet traveled the entire world but I have been to several European, Caribbean and African countries to visit or to live and I have seen the many beautiful faces just like the ones upon the pages of *I Saw Your Face*. I can feel the words and hear the laughter from these children while imagining them reading the poetic dedication by Dawes who has witnessed their existence around the world. Through the timeless collection of Tom Feelings' artwork of children from near and far, I have seen the faces of those children in Johannesburg, Gaborone, Dakar, Accra, Cape Coast, Kingston, New York, Charleston, Detroit, Chicago, and Bloomington. And in each illustration of a child that was selected to accompany Dawes' words there is a far away look in the child's eyes combined with a soft smile of contentment.

This book was to inspire children and to celebrate survival, honor, respect and love through narrative and visual images. Its purpose was to deliver positive messages that will counteract the stereotyped texts and images that sometimes appear in literature for children. *I Saw Your Face* allows children of all colors to know that brown faces can be found around the world.

Dawes united with Feelings to create an African Diasporic connection dedicated to children. Ghanaian born and Jamaican raised, Dawes now lives in South Carolina with his family. His poetry is an array of his heritage and his travels. He has been able to connect cultures through emphasizing the importance of identifying differences within the culture as well as finding similarities to associate with others. And just like Dawes' adult work he has now recognized that Black children cannot be placed within one exclusive life style, thought, cultural understanding or image.

Richard J. Powell's discovery that the blues aesthetic could be found within the visual artwork of Black artists suggested that the blues was essentially a state of mind. Powell defines the function of the blues aesthetic as twofold, giving two possibilities for how it is created. Feelings' work can be identified within both of Powell's explanations: "It can either inspire an artist to create a particular work, or it can actually be the model upon which a work is created. To a great extent, if one is knowledgeable about Afro-America ~ its

history, its traditions, its geography, its verbal and visual codes, its heroes, its demons, its ever changing styles, and its spiritual dimensions ~ then one knows the blues" (21).

The ability to dream and to imagine is present in Feelings' imagery as well as in the words of Dawes, Greenfield and Grimes. Feelings' soft sketches turned characterizations that had been perceived so negatively in the books of an earlier era into images of beautiful young dreamers, looking forward to their futures.

> They will not be the same
> after this growing time,
> this dreaming. . . (Greenfield)

The Black voice is significant within the poetry of Dawes, Greenfield and Grimes. Their words connect with Black children either to soothe or to relate to them. Stephen Henderson states, "Poets use Black speech forms consciously because they know that Black people ~ the mass of us ~ do not talk like white people. They know that despite the lies and distortions of the minstrels ~ both ancient and modern, unlearned and academic ~ and despite all of the critical jargon about "ghettoese" and "plantation English," there is a complex and rich and powerful and subtle linguistic heritage whose resources have scarcely been touched that they draw upon" (33). It is this voice that lyrically attaches to the imagery of words that culturally connect to Black children.

Greenfield and Grimes' partnerships with Tom Feelings changed the illustrated book from being merely a "picture book" to being a unique poetic experience in children's verse and vision. Can an illustrator be a poet?

Tom Feelings is part of the blues movement, creating illustrations of children that stand alone, but who are not sad. The illustrations do not follow a storyline but create a mood that is backed up by poetic words ~ a blues mood that allows glimpses of young, solo artists that have a story to tell . . . one day, but for now they will just dream about it. Feelings, Greenfield, Grimes and Dawes have been able to place Black children's picture books upon another level. This level can be described as "a celebration of the sensual" created so that Black children know that they are allowed to dream (14). Poetic words that welcome and warm a child's senses; that allow that child to walk barefoot upon the pages and curl up among a phrase, this level of poetry is homemade

and makes them know that shades of brown are beautiful and worth celebrating everyday.

## Daddy Blues

Dianne Johnson mentions in *Telling Tales* (1990) how important it is for Black children to have the "experiences of dreaming and imagining other realities, other worlds, and possibilities" (2). She includes in her example Langston Hughes' *Dream Keeper* (1932) because the primary focus of the poetic collection is to inform children that they have the ability to dream and soar through their imagination. In the audible recording of *The Dream Keeper* (1955) Hughes explains to the listener between recitations what inspired him to write that particular poem. He states that dreams are important for children to possess and that the accomplishments by great inventors and explorers "grew out of dreams" which is followed by his reciting *Dreams*:

> Hold fast to dreams~
> For if dreams die
> Life is a broken winged bird
> That cannot fly. (3)

But sometimes dreams are shattered and life takes an unexpected turn. One moment life is steady, happy and all family members are in place and the very next moment that familiar world has become an unwelcomed stranger. In Hope Anita Smith's *The Way a Door Closes* (2003), thirteen-year old C.J.'s loving family faces unexpected pains now that his father has been released from his job.

Smith's poetry sings a medley of the unemployment daddy blues. A father released from a job is discouraged because he is unable to support his family. C.J. explains that he "can tell a lot by the way a door closes" what type of mood the person that closes it is in. Shane W. Evans illustrates just the backs of C.J. and his two younger siblings staring at the front door that has just closed behind their father. C.J. sensed that his father walked out the door the wrong way.

> I felt all the air leave the room
> and we were vacuum - sealed inside. (20)

C.J. lives in brutal honesty clothed in metaphorical grace. He searches through photographs for some indication, some sort of sign, some overlooked notification that his father would leave one day but finds nothing. And perhaps because there were no clues he believes that his father is not gone for good. Even when he hears his mother weeping and is told by friends that a father returns home "once in a blue moon," C.J. holds onto the thought that he will (42). C.J. struggles to hold his head up waiting for that blue moon to appear.

*The Way a Door Closes* approaches a situation that is not unknown. In the last decade it was estimated that 60% of all children that were born in the 90s would be fatherless before they became adults (Peart, Pungello, Campbell & Richey, 2006, 71). Where are the blues songs for these children? What age do you have to be to get the blues? The blues is not age regulated. C.J. struggled to keep hope alive. He refused to believe the odds while maintaining the dream that his father would return and looked up one day to see a blue moon shining.

> But let me tell you what a
> blue moon
> looks like.
> It's my dad
> coming home after being gone what seemed like forever. (52).

The ability to dream involves free flowing imagination opposing the impossibilities. This ability to know the impossible is the focus of *In Daddy's Arms I Am Tall: African Americans Celebrating Fathers* (1997), a poetry collection illustrated by Javaka Steptoe. For many years children's picture books contained very few images of the Black father. It seemed at one time that Black fathers just did not exist in picture books at all. It is true that not all Black families have father figures, but it is also true that many do. Within the pages of *In Daddy's Arms I Am Tall* a variety of poems celebrate Black fathers. These poems accompany collage images created by Javaka Steptoe, son of John Steptoe.

The images that represent each poem can be described by the stylization of process within the blues. A multitude of natural earth mediums create a blues mood that details the settings and the faces of the illustrated Black fathers.

The crooked fishing hat upon a father's head, the straw hat upon daddy farmer's head, and the simple yet universal cut out of a child's head lying upon the shoulders of a father all reflect what is rarely seen in the media, but privately viewed in many households across the United States. Society has almost made Black fathers connected to families a myth, showing mainly the sour elements without a clear balance of the sweet. Earl Ofari Hutchinson describes the other side:

> That's part of the story. Many black fathers do stay in the home. They sacrifice to provide the necessities for their wives and children. They overcome mountainous obstacles to build strong relationships with their loved ones. They roll up their sleeves, put their chin to the grindstone and go forward. (17)

In Davida Adedjouma's poem "Artist to Artist," a father's dream to be a visual artist is put aside to provide for his family. Adedjouna reflects upon his sacrifice.

> he dressed in the blue uniform & black shoes
> of many other fathers who also weren't doctors or lawyers,
> teachers or preachers, & rode the 10:00p.m. bus
> to the downtown post office. Sorted mail by zip code ~
> 60620, 60621, 60622. He sorted mail all night &
> into the day because we had bills to pay. For 30 years (23)

Now retired, the father is asked by his daughter poet, "what do you want to be?" It is that "optimistic faith in the ultimate triumph of justice" that is brought forth (14). It is the thought that he now has the opportunity to be an artist so that a dream deferred can finally advance. A daughter now dreams for her father's dream to come true. And it is the small crayon image of a capped father drawing while his daughter sits next to him watching that visually interprets the poem.

Javaka's own poem "Seeds" sows the message that his creativity was planted from his father's words. Seeds, leaves and tree branches are the visual accompaniment that explains, "I became the words I ate in you" (22). Javaka Steptoe's visual dedication to fathers can be seen as the ultimate form of honor possible by an artist that is the son of one of the pioneers in Black children's literature.

There is a bridge where the railroad tracks are not new but less traveled. Passengers that ride this train travel from Black adult literature to Black children's literature. One of the passengers that crossed this bridge for many years was Langston Hughes. In the early twentieth century, Hughes along with others constructed it. Carolyn Fowler states, "Thus Langston Hughes can serve as bridge and image of almost all the periods and tendencies of black literature in the twentieth century" (168). And now in the twenty-first century Langston Hughes's literary work is part of the foundation of Black children's literature and can be seen throughout its landscape.

Black poetry for children continues to present marvelous messages of hope, freedom and acceptance through Hope Anita Smith, Eloise Greenfield, Nikki Grimes, Kwame Dawes and many others. Images created by Javaka Steptoe, Shane Evans, and Tom Feelings accompany these poems like the musicians that once accompanied Hughes when he recited poetry in various clubs across the country.

In his preface to *I Am the Darker Brother* (1968) Arnold Adoff states, "There is a need for Negroes to know of and experience through the eyes of other Negroes how it has been and how it is to be a Negro in America, and for whites to become familiar with this part of their American heritage through the vision of life as Negroes in this country see it" (10). Adoff's words still hold true today. It is important for Black children to see images and feel words that they can identify with. He states, "I have worked to create collections of Black American poetry for young readers: in attempts to help us reach some level of multiracial/multi-cultural reality in our culture, in our literature ~ to go beyond the so-called "American" literature texts I encountered as student and teacher" (10). Adoff was determined when he began his literary career that he would correct a wrong that had been done in his own educational experience.

Kwame Dawes and Tom Feelings expanded their words and images past North America to inform children that Black children can be found all over the world. Words and rhythms that disclose blackness come alive, as lessons are taught, hearts are soothed, funny bones tickled and dreams freely soar in the minds of young Black readers. These poets, whether they place their blues rhythms on a sheet of paper or on blank canvases, share their expressions of freedom; they share their imaginations and dreams to motivate young dreamers.

Bring me all of your dreams,
You dreamers,
Bring me all of your
Heart melodies
That I may wrap them
In a blue cloud-cloth
Away from the too-rough fingers
Of the world.  (1932)
Langston Hughes , *The Dream Keeper and Other Poems*

# A Blues Ending

Why should flesh-colored Band-Aids always be pink?
Audre Lorde (1980,473)

Imagination, by definition, is freedom
Carolyn Fowler (1981, viii)

Black children's literature is still unknown territory to many in the literary field. This literature has been treated like Ralph Ellison's invisible man, maintaining features similar to Black literature moving throughout historical periods from the Harlem Renaissance to 9/11, yet not many know it by name.

The blues aesthetic was used as my instrument because the blues has been able to define the Black experience expressively and expansively. I have discovered that many Black artists have pushed aside W.E.B. Du Bois' definition of double consciousness by removing the shackling phenomenon of judging oneself through the eyes of others. Black children's literature is about Blacks looking at themselves the way they look at themselves. James Baldwin states, "The artist cannot and must not take anything for granted, but must drive to the heart of every answer and expose the question the answer hides" (1962, 316). Black artists have placed themselves inside the literature in order for Black children to look at <u>them</u> and see a more positive and / or real image of themselves inside stories. In her article "A Sign of Having Been There," Jacqueline Woodson states, "As people who exist on the margins, we do have a different view of the world, and it is our responsibility to refocus. In the course of refocusing, we may help a child who is coming out or struggling with abuse or with family or with health to acquire a clearer vision of the world and thereby grow up stronger" (713). For many Black children sitting in classrooms throughout the United States it is very seldom that they see their image inside assigned readings. A large amount of children throughout their educational

experience learn very little about the positive historical events and achieve-
ments of Black scholars, scientists, inventors and artists that have contributed
to the advancements of the United States let alone the world.

Black children's literature has been in existence for over one hundred
years and its progression up until today has been an achievement in the Black
literary field. But who knows about it? Children's literature is a large industry
yet Black children's literature is still lost in most mainstream bookstores (if
there at all), not included in classrooms (except on specific dates or months)
and / or omitted from anthologies specifically focused upon children's litera-
ture or Black literature. If Black children's literature were a person it surely
would have the blues!

The books chosen lighten a mental load for children that struggle with the
unknown. Many Black children are walking in the dark. They are alienated,
degraded, and force-fed literature by publishers, school systems, and teachers
that do not believe they exist as conscious readers. James Baldwin states, "The
precise role of the artist, then is to illuminate that darkness, blaze roads
through that vast forest, so that we will not, in all our doings, lose sight of its
purpose, which is, after all, to make the world a more better dwelling place"
(315). So these books have the ability to enlighten not just Black children but
all children. It is necessary for these books to be taken out of the holiday closet
to be recognized as a daily light of mental nourishment for children.

There have been to date no literary guidelines that position Black chil-
dren's literature within the context of the blues aesthetic, so I used this adult-
size instrument and delicately worked my way around areas that might be mis-
understood. In "Songs Called the Blues," Langston Hughes describes the vari-
ety of blues that are present at that time and his hopes on future blues
developments. In his conclusion Hughes explains that the "Blues are still be-
ing made" (143-144). Identifying the blues aesthetic in various Black children's
literature may be a new development but not one that is inconceivable.

In his review of LeRoi Jones' *Blues People*, Ralph Ellison states,

> The blues speak to us simultaneously of the tragic and the comic aspects of the
> human condition and they express a profound sense of life shared by many Negro
> Americans precisely because their lives have combined these modes. This has been the
> heritage of a people who for hundreds of years could not celebrate birth or dignify
> death and whose need to live despite the dehumanizing pressures of slavery developed

an endless capacity for laughing at the their painful experiences. This is a group experience shared by many Negroes, and any effective study of the blues would treat them first as poetry and as ritual. (256)

Today, Black children are exposed to media images that regularly eliminate images or experiences that they can fully identify with. Society forces children many times to look into distorted mirrors. Carolyn F. Gerald states in her essay "The Black Writer and His Role," "The black child growing into adulthood through a series of week – end movies, seeing white protagonists constantly before him projecting the whole gamut of human experience, is, in extreme cases, persuaded that he must be white, or (what is more likely), he experiences manhood by proxy and in someone else's image. He sees, in other words, a zero image of himself" (352). How is it possible that an article written in 1971 still holds true today? It is all right to daydream from media created images showing different lands, families, and situations but it would be beneficial and thoughtful for the Black child to be able to dream in color every once and a while. And when I state "in color" I do not mean in stereotypical colors that come boxed safely with just eight crayons but I am referring to the ninety-six variety pack that allows a child to soar above oppression like Cassie Lightfoot, envision African ancestors like Jacob, courageously accept one's own image like Sudan, or even celebrate with the community the day of your birth, like Javaka.

## A Blues Lens

Children do not have the exact same blues as adults, so theories had to be examined through a different lens. A youthful lens makes it possible to discuss the unemployment blues. In Faith Ringgold's *Tar Beach*, the main topic of discussion was Cassie Lightfoot's father's unemployment. In *The Way a Door Closes* C.J.'s father leaves the home after feeling helpless and hopeless once released from his job. Are we to continue to believe that children are oblivious to their surroundings? They may not be the one unemployed but they are affected by the circumstance and they too have to live through it.

If new blues categories for children were added one prominent one would be "My Teacher Blues" due to so many teachers that omit literature written by

authors of color because they do not understand it. Songs could be sung about teachers that believe that it is all right to belittle children in a classroom because they do not have the same background as the other children. Or perhaps a blues tune about teachers that believe that it is not necessary to teach books that include any other image besides white. Ujamaa's teacher caused him grief just because she was unaware of her own culture. James Baldwin believed "if we understand ourselves better, we would damage ourselves less" (317). In *All Us Come Cross the Water*, Ujamaa was able to investigate his origins despite his Black teacher, who showed no sign of cultural awareness herself. Ujamaa's teacher decides that instead of assisting her Black students with an assignment about where their people came from, she ridicules and degrades them, which means she degrades herself. So is Ujamaa the only child to have the-omission-of-learning-about-my-culture blues?

Many Black children because of an incarcerated parent or sibling sing various renditions of the prison blues. Through books such as *Visiting Day* children may be able to acquire a feeling of hope knowing that they are not alone. Identity, family, and economics can all be blues topics for many children along with the school and friendship blues.

Blues characters within Black children's literature are the grandmothers that are now raising second and third generations for whatever reason. We very rarely see a grandfather in these stories but I know that the grandfather is also a blues character just for the fact that he is invisible. Literature often omits him. But for my children and many other children their grandfathers are definitely blues men. A barber, factory worker, postal employee, migrant worker, teacher or businessman ~ these elder blues men tell their stories to their grandchildren in order for them to know how they triumphantly got ovah.

The image of the blues child that I have presented throughout this book is the young poet that travels to Mexico to visit his father while his mother lives in the United States. The little boy that believes the color of his skin equates to everything negative. The young girl that knows that because her family is Black, her father will have a difficult time getting jobs. A blues family is the one that wakes up before the sun to go pick cotton in Southern California. Or they wait and pray that their father walks back into the door and back into their life. It is also that household that is made up of aunts, uncles, a mother,

a grandmother, and cousins that are held together by love. And a blues moment is walking on the railroad tracks at night with your siblings knowing that you are not supposed to be there; the bus ride with a packed lunch on the way to visit a relative in prison; listening to a singing father picking cotton and a mother that hums along; and receiving a letter from the mailman from your mother who is working on the railroad in Chicago.

In Jeffrey Stewart's essay "Given the Blues" much of what he states about "adult" blues can, on a smaller scale, also comply with childhood blues.

> The blues is not just the language of oppression and the realization that there's no way out of this belly of racist capitalism. It is the ability to overcome, to use the riffs of an expressive African or African-American bag of hoodoo licks to sing a song of transcendence, of madcap joy in the midst of all hell. It is the ability to laugh to keep from crying, to open the heart instead of shutting it once she's gone, and to say "I didn't want the _____ anyway." The blues is perhaps best represented by the concept of irony that connects us to the slave's experience of building America, from sunup to sundown, and being called lazy. (89)

In Black children's literature there are situations such as in *Birthday*, where an entire family and community move away from America in order to live without the restrictions caused by skin color. A social issue is now brought forth through the imaginative creation of John Steptoe that shows Blacks that celebrate family and community. This book could be looked at as brutal honesty clothed by metaphorical grace. Black writers have freely used their imaginations in order to get a message across.

Ralph Ellison makes readers understand the unpleasant conditions for a Black man within the United States by creating a character that is symbolically invisible because of the treatment he has received because of his race and gender. This theme is also suggested in *All Us Come Cross the Water* with the character Tweezer. Tweezer does not have a name because his great grandfather left his name behind in Africa in order to retain a piece of his freedom and dignity.

Ellison uses the obscurity of a paint factory in which the process of making the paint whiter and brighter requires adding a black liquid substance. For over sixty years the majority of the American public is not aware that Rosie the Riveter also represented Black women (and Latina women). It is in *Coming On Home Soon* that Jacqueline Woodson unveils one of the other shades of Rosie.

600,000 Black women worked in order for the United States to survive World War II. Do we need a new poster?

Ellison creates a basement apartment for this invisible man. This apartment is lightened by 1369 light bulbs above his head. In *The Black Snowman* a piece of kente cloth that mysteriously survived the middle passage *and* slavery (just like Black culture) is found on the ground, and when tied around the neck of a soot covered snowman he comes to life to preach the beauties of blackness to a disenchanted Black boy. Which level of storytelling gets the message across? Is one message stronger than the other?

## The Literature Used

the night the tv broke
they gave me
books
no sound and no screen
but i heard and saw
anyway.

The collection of books used have all been written by Black writers. Each one performed riffs that allowed the audience to enjoy solo acts, but once ended, the audience should be able to recognize that these literary songs were dedicated to Black children. Walter Dean Myers confirms his dedication to writing for Black children by stating:

> As a Black writer I want to talk about my people. I want to tell the reader about an old Black man I knew who told me he was God. I want to tell a reader how a blind man feels when he hears that he is not wanted because he is Black. I want to tell Black children about their humanity and about their history and how to grease their legs so the ash won't show and how to braid their hair so its easy to comb on frosty Winter mornings. (155)

Many of the writers I used such as Lucille Clifton, Nikki Giovanni, Tony Medina, Sherley Anne Williams, Langston Hughes, Ntozake Shange, and Kwame Dawes have written adult literature that reflect Black cultural experiences. How is it possible to value their adult work and not their work targeted for a younger reader?

Stories that were filled with exaggeration, brutal honesty, optimism, and artistic sensual impression were all part of the communal consciousness that sees Black children for who they are ~ children. Why do books for children of color have to all be realistic? Sudan stared into the mirror at a lion that looked back at him with a smile. Cassie Lightfoot faced racism by dreaming that she could resolve her father's dilemma by flying over the union building that banned him because he was not white. Ntozake Shange poetically admitted that she lives in music and not speaking for anyone else, I sometimes do too. Is it imperative that a Black child only be presented with serious topics? Why is it that white children can make wishes, dream of other worlds, and possess magical powers while Black children can only read about them in envy? Brutal honesty would state that Black children have been cheated in literature in the United States through the sorting of literary genres that place fantasy as a privilege that Black children are not allowed to participate in.

Houston Baker's railroad metaphor helps to explain the blues aesthetic because of the tracks that connect to this blues juncture. A variety of literature styles that can fit within various other categories of writing yet they also sit on the track that connects back to the blues aesthetic. And with his theory I set up tracks that lead trains past Black children's literature to the images that are regularly seen within the blues aesthetic literature. Railroads, journeys, prisons and inner city living are all visual symbols within the blues aesthetic; *Shortcuts*, *Bigmama's*, *Visiting Day*, *DeShawn Days*, and others utilized those exact symbols. I discovered that many of the books I used contain strong cultural meanings and portray various Black cultures across the United States. These books are as political as some adult books and as soothing as an old quilt on a cold night. Boys by the name of C.J., DeShawn, and Jacob, a young girl going to the fields with her family to pick cotton while Cassie's imagination soars across the sky to empower her family, and a little boy named Sudan that wears dreadlocks make for stories that children can relate to, learn from and enjoy.

The purpose of this book is to inform those that perhaps do not realize how important Black children's books are for Black children. I can relate to the statement by Jacqueline Woodson:

> . . .searching the pages of the books available to me for people like my people; reading the books where I found tiny pieces of myself over and over again. I didn't grow tired of reading these books, because I couldn't afford to. What else was there? So few

books published in the 1970s reflected the existence of marginal people – and already, at nine, ten, eleven, I understood myself to be marginal. Every white face on my television, in my textbooks, in my newspaper reiterated the fact that I was not a part of the majority. (712)

From the literature that I have selected and analyzed, a teacher or parent could select books to read to children with a clearer understanding about what the author and/or the illustrator was trying to convey about themselves and their culture. My purpose was to construct an easier way to select books about other cultures and feel comfortable enough to read them during any season not just on special culturally related days. These books are now samples for practical use and for scholarly comparative endeavors.

This study emphasized one aesthetic mode, but it also demonstrated the indissoluble tie between aesthetic and sociological elements of literature. The beauty of the blues aesthetic and the sometimes grim, historical context of a story clearly indicated that a holistic critical method is essential if a valid critical assessment is to be achieved.

The blues aesthetic is a forever changing entity that also stays the same. It is a reflection of the experiences of Blacks throughout the United States; it changes but never forgets where it sits. This aesthetic is not a part of slavery but an important part of freedom. It is the freedom to hurt; it is the everyday occurrences in one's life; it is the sad times as well as the happy times; it is also the signifying of how one got "ovah." In an interview, Mississippi Blues artist Willie Dixon stated that the spirituals and the blues are basically the same:

One they called a spiritual, and the other was called the blues. And the only difference was that one of them was dedicated to the earth and the facts of life, which was the blues, and the spiritual things were dedicated to heaven and after death, you know. So that was the difference between the spirituals and blues. And the experience you receive on earth was the only thing you had to go on because nobody had the experience of heaven. (208)

The blues is the realization of the things that you do not have. It is the awakening of independence and it is the emotional orientation toward conditions that you cannot change but wish you could. It is the secular equivalent to spirituals and the downbeat of jazz. The blues is not just musical but emotional. It tells the listener, the reader or viewer that he/she is not

alone in the circumstance being confronted. In educational terms this practice is called bibliotherapy. To sooth and comfort a child that is going through a difficult situation, a book can be recommended that can relate to the circumstance and allow the child to realize that he/she is not alone. Bibliotherapy also advances the child's acceptance of the contradictory nature of life ~ that is, life is both sweet and sour and we learn to accept both and hope that the sweet comes more often.

The blues, I have discovered, is about Black life. It alludes to experience whether racial, political, economical, or sociological. When the blues aesthetic is placed within literature it changes the book into a radical thinking instrument. The "happy ever after" endings are gone and the "life will go on" stories begin. For children this opens up their thinking skills, their research skills and expands their minds with respect to human difference and human similarities.

The blues aesthetic, mostly known for its musical qualities, is also a social condition, a literary movement and a state of mind. My stand has been that some of Black children's literature contains the blues aesthetic. I've mixed old Black voices with new Black voices to demonstrate how the blues has evolved and how it continues to expand and create new tracks along the way yet it can still be identified as a familiar landing. Langston Hughes described the making of the blues as something very sad, but he also described within the same sentence the blues as "a strong sense of determination, a love of life, and a feeling of humor that makes people laugh!" (8). How could Black children's literature not be noticed since it contains all of these qualities?

> We are hurting
> We are dying
> For a noveau blues
> To undeline
> What's left behind (2005, 573)
> Yusef Komunyakaa, *New Blues*

Black children's literature is part of a new blues aesthetic that has not been left behind but has continued to survive with or without recognition by scholars across the country. It is now necessary to wonder if we can actually afford to continue to ignore this part of Black culture that only sixty years ago was seen by Black scholars, writers and artists as one of their most precious treasures.

Black children are hurting throughout the United States and many are dying. They are being deprived of basic necessities including education which involves the literature that can relate and enrich their state of mind and their spirit. For so many Black children across the United States they, like the literature mentioned in this book, truly got de blues.

Adoff, Arnold. "Politics, Poetry, and Teaching Children: A Personal Journey." *The Lion and Unicorn*, 10, 1986, 9-14.

———. *I Am The Darker Brother*. Illustrated by Benny Andrews. New York: MacMillan, 1968.

Anderson, Karen Tucker. "Last Hired, First Fired: Black Women Workers during World War II," *The Journal of American History*, Vol. 69, No.1, June 1992, 82-97.

Anyidoho, Kofi. *AncestralLogic & CaribbeanBlues*. New Jersey: Africa World Press, Inc. 1993.

Baker, Augusta. "The Changing Image of the Black in Children's Literature." *The Horn Book*, February 1975, 79-88.

———. "Guidelines for Black Books: An Open Letter to Juvenile Editors." *What Black Librarians Are Saying*, ed. by E. J. Josey, Metuchen: The Scarecrow Press, Inc. 1972.

———. "Reading for Democracy." *Wilson Library Bulletin*, October 1943, 140-44.

Baker Jr., Houston A. *Blues, Ideology, and Afro-American Literature: A Vernacular Theory*. Chicago: The University of Chicago Press, 1984.

———. *Black Literature in America*. New York: McGraw-Hill Book Company, 1971.

———. *Long Black Song: Essays in Black American Literature and Culture*. Charlottesville: The University Press of Virginia, 1990.

———. "To Move without Moving: An Analysis of Creativity and Commerce in Ralph Ellison's Trueblood Episode." *PMLA*, 98, October 1983, 828-845.

Baker Jr., Houston A. and Charlotte Pierce - Baker. "Patches: Quilts and Community in Alice Walker's 'Everyday Use'." *Southern Review*, 21, 1985, 706-720.

Baldwin, James. "The Creative Process," *The Price of a Ticket; Collected Nonfiction 1948 – 1985*. New York: St. Martin's / Marek, 1985.

Baraka, Amiri. "Black Art." *The Black Scholar*, January/February 1987, 23-30.

Baraka, Amiri and Amina Baraka. *Black Music*. New York: William Morrow and Company, Inc., 1987.

Barnwell, Ysaye M. *No Mirrors in My Nana's House*; paintings by Synthia Saint James. San Diego: Harcourt Brace, 1998.

Bartlett, Andrew. "Airshafts, Louderspeakers, and the Hip Hop Sample: Contexts and African American Musical Aesthetics." *African American Review*, 28, 4, 1994, 639-652.

Bell, Bernard W. "Contemporary Afro-American Poetry as Folk Art." *Black World*, March 1973, 16-26, 74-87.

——. "Folk art and the Harlem Renaissance." *Phylon*, 2, June/Summer 1975, 155-163.

Bell-Scott, Patricia, Beverly Guy-Sheftall, "Introduction", *Double Stitch: Black Women Write About Mothers & Daughters*. Boston: Beacon Press, 1991.

Ben-Israel, Ben Ammi. "The Prophecy." *Essence*, February 1996, 54.

Bishop, Rudine Sims. *Shadow & Substance*. Urbana: National Council for Teachers of English, 1982.

——. "Walk Tall in the World: African American Literature for Today's Children." *Journal of Negro Education* 59, 4, (1990): 556-565.

Bone, Robert. "Ralph Ellison and the Uses of Imagination." *Modern Black Novelists*. Edited by M.G. Cooke, Englewood Cliffs: Prentice-Halls, Inc., 1971.

Bontemps, Arna. "Sad - Faced Author." *The Horn Book Magazine*, January / February 1939, 7-12.

Brooks, Gwendolyn, Keorapetse Kgositile and Haki R. Madhubuti. *A Capsule Course in Black Poetry Writing*. Detroit: Broadside Press, 1975.

Brown, Claude. *Manchild in the Promised Land*. New York: The Macmillan Company, 1965.

Brown, Sterling. "The Blues." *Phylon*, vol. XIII, 4, 1952, 286-292.

Bryan, Ashley. "A Tender Bridge." *Journal of Youth Services in Libraries* (Summer 1990): 295-302.

Bureau of Justice Statistics. "Incarcerated Parents and Their Children". Washington D.C.: U.S. Department of Justice, August 2000.

Byrd, Donald. "The Meaning of Black Music." *The Black Scholar*, Summer 1972, 28-31.

Cephas, John. "The Blues." Edited by Richard J. Powell. *The Blues Aesthetic: Black Culture and Modernism*. Washington D.C.: Washington Project for the Arts, 1989, 15-17.

Chinitz, David. "Literacy and Authenticity: The Blues Poems of Langston Hughes." *Callaloo*, 19.1, 1996, 177-192.

Clifton, Lucille. *All Us Come Cross the Water*. Illustrated by John Steptoe. Canada: Holt, Rinehart and Winston of Canada, Limited, 1973.

Cone, James H. *The Spirituals and the Blues*. New York: Orbis Books, 1989.

Cooper, Floyd. *Coming Home From The Life of Langston Hughes*. New York: Philomel Books, 1994.

Crews, Donald. *Bigmama's*. New York: Mulberry Books, 1991.

——. *Shortcut*. New York: Mulberry Books, 1992.

Danker, Frederick E. "Blues in the Classroom." *English Journal* 62, (March 1973): 394-401.

De Veaux, Alexis. *An Enchanted Hair Tale*. Illustrated by Cheryl Hanna. New York: Harper Collins Publishers, 1987.

Dick, Bruce. "Richard Wright and the Blues Connection." *Mississippi Quarterly*, 42, Fall 1989, 393-408.

Dorson, Richard M. ed. *American Negro Folktales*. Connecticut: Fawcett Premier Book, 1967.

Dover, Cedric. *African American Visual Aesthetics: A Postmodernist View*. Ed. David C. Driscoll. Washington D.C.: Smithsonian Institution Press, 1995.

——. *American Negro Art*. New York: New York Graphic Society, 1960.

Du Bois, W.E.B. *Darkwater, Voices From Within the Veil*. New York: Schocker Book, 1920.

——. *The Souls of Black Folk*. New York: Alfred A. Knopf, 1903.

Ellison, Ralph. *Invisible Man*. New York: Random House, Inc, 1947.

——. *Shadow and Act*. New York: Random House, 1964.

——. "Stormy Weather." *New Masses*. September 24, 1940, 20-21..

Feelings, Tom. "Illustration Is My Form, The Black Experience My Story and My Content." *The Advocate*, 4, 2, 1985, 73-83.

——. *Daydreamers*. Written by Eloise Greenfield. New York: Dial Books for Young Readers, 1981.

——. "The Artist at Work: Technique and the Artist's Vision." *The Horn Book Magazine*, November / December 1985, 685-695.

——. *I Saw Your Face*. Written by Kwame Dawes. New York: Dial Books for Young Readers, 2004.

——. *Something On My Mind*. Written by Nikki Grimes. New York: Dial Books for Young Readers, 1978.

Floyd Jr., Samuel A. *The Power of Black Music: Interpreting Its History from Africa to the United States*. New York: Oxford University Press, 1995.

Fowler, Carolyn. *Black Arts and Black Aesthetics; A Bibliography*. Georgia: First World, 1981.

Fry Ph.D., Gladys - Marie. *Stitched from the Soul; Slave Quilts from the Ante-Bellum South*. New York: Dutton Studio, 1990.

Garon, Paul. *Blues and the Poetic Spirit*. San Francisco: City Lights, 1996.

Gaunt, Kyra D. *The Games Black Girls Play: Learning the Ropes from Double - dutch to Hip - hop*. New York: New York University Press, 2006.

Georgia Writers Project - Work Projects Administration. *Drums and Shadows*. Athens: The University of Georgia Press, 1940.

Giddings, Paula. *When and Where I Enter: The Impact of Black Women on Race and Sex in America*. New York: Bantam Books, 1984.

Giovanni, Nikki. *Quilting the Black - Eyed Pea; Poems and Not Quite Poems*. New York: HarperCollins, 2002

——. ed. *Shimmy Shimmy Shimmy like My Sister Kate*. New York: Henry Holt and Company, 1996..

Goines, Leonard. " The Blues as Black Therapy: A Thematic Study." *Black World*, November 1973, 28-40.

Gouma-Peterson, Thalia. "Faith Ringgold's Narrative Quilts." *The Horn Book Magazine*, January/February 1939, 7-12.

Greenfield, Eloise. "Something to Shout About." *The Horn Book Magazine*, December 1975, 624-626.

Gwaltney, John Langston. *Drylongso: a self portrait of Black America*. New York: Random House, 1980.

Hale, Janice E. *Unbank the Fire: Visions for the Education of African American Children*. Baltimore: The John Hopkins University Press, 1994.

Hamilton, Virginia. "Everything of Value: Moral Realism in the Literature for Children." *Journal of Youth Services in Libraries*, (Summer 1993): 363-377.

——. "On Being a Black Writer in America." *The Lion and the Unicorn*, 1986, 15-17.

——. *The People Could Fly; American Black Folktales*. New York: Knopf, 1985.

Harrison, Daphne Duval. *Black Pearls: Blues Queens of the 1920s*. New

Brunswick: Rutgers University Press, 1990.

Henderson, Stephen. "The Blues as Black Poetry." *Callaloo*, No. 16, October 1982, 22-30.

———. *Understanding The New Black Poetry; Black Speech & Black Music As Poetic References*. New York: William Morrow & Company, Inc., 1973.

Hilliard, Asa G. "Conceptual Confusion and the Persistence of Group Oppression Through Education." *Equity & Excellence*, 24, 1, Fall 1988, 36-43.

Hood, Robert E. *Must God Remain Greek? Afro Cultures and God Talk*. Minneapolis: Fortress Press, 1990.

hooks, bell. *Salvation; Black People and Love*. New York: William Morrow, 2001.

Howell, Peg, Leg. "Turtle Dove Blues." *Blues from Georgia*. Roots. LP RL 309, 1928.

Huggins, Nathan Irvin, ed. *Voices From the Harlem Renaissance*, New York: Oxford University Press, 1995.

Hughes, Langston. *The Big Sea*. New York: Harper Collins, 1940.

———. *Black Misery*. New York: Paul S. Erikkson, Inc. 1969.

———. *The Collected Poems of Langston Hughes* edited by Arnold Rampersad. New York: Vintage Books, 1994.

———. *The Dream Keeper and Other Poems*. Illustrations by Helen Sewell. New York: Alfred Knopf, 1932.

———. *The Dream Keeper & other Poems of Langston Hughes*. New York: Folkways Records, 1955.

———. "The Negro Artist and the Racial Mountain." *The Nation*, Vol. 122, June, 1926.

———. "Songs Called the Blues." *Phylon* (1940 – 1956), Vol. 2, No. 2 (2$^{nd}$ Qtr.1941), 143-145.

Hughes, Langston and Arna Bontemps, ed. *The Book of Negro Folklore*. New York: Dodd, Mead & Company, 1959.

———, ed. *The Book of Negro Humor*. New York: Dodd, Mead & Company, 1966.

Hurston, Zora Neale. "Characteristics of Negro Expression."(1935), *Voices from the Harlem Renaissance*, edited by Nathan Irvin Huggins. New York: Oxford University Press, 1995.

Hutchinson, Earl Ofari. *Black Fatherhood: the Guide to Male Parenting*.

Inglewood: IMPACT, Publications 1992.

Jackson, Evalene P. "Effects of Reading Upon Attitudes Toward the Negro Race." *The Library Quarterly*, January 1944, 47-55.

Johnson, Carolyn E. "Communion of Spirits." *Expressively Black*, edited by Geneva Gay and Willie R. Baber, 293-320. New York: Praeger, 1987.

Johnson, Dianne. "I See Myself." *American Visions*, December 1990, 18-20.

——. *Telling Tales; The Pedagogy and Promise of African American Literature for Youth*. New York: Greenwood Press, 1990.

Johnson, James Weldon. *Autobiography of an Ex-Coloured Man*. New York: Hill and Wang, 1927.

Jones, Bill T. with Peggy Gillespie. *Last Night on Earth*. New York: Pantheon Books, 1995.

Jones, Gayl. *Liberating Voices; Oral Tradition in African American Literature*. New York: Penguin Books, 1991.

Jones, LeRoi. *Blues People*. New York: Morrow Quill Paperbacks, 1963.

Joyce, Joyce A. "Gil Scott - Heron: Larry Neal's Quintessential Artist." *So Far So Good, Gil Scott-Heron*, Chicago: Third World Press, 1990.

Karenga, Ron. "Black Cultural Nationalism." In *The Black Aesthetic*. Ed. Addison Gayle, Jr., 31-37, New York: Anchor Books, 1971.

Keats, Ezra. *The Snowy Day*. New York: Viking Press, 1962.

Keil, Charles. *Urban Blues*. Chicago: University of Chicago Press, 1966.

Kelly, Margot Anne. "Sister's Choices." *Quilt Culture; Training The Pattern*, Edited Cheryl B Torsney and Judy Elsley, Columbia: University of Missouri Press, 1994, 49-67.

Klotman, Phillis R. "Langston Hughes's Jess B. Semple and the Blues." *Phylon*, 36, 1975, 68-77.

Kohl, Herbert. *Should We Burn Babar?* New York: The New Press, 1995.

Komunyakaa, Yusef. "New Blues." *Callaloo*, 28.3, 2005, 573 - 574.

Law, Robin and Kristin Marnn. "West Africa in the Atlantic Community: The Case of the Slave Coast." *William and Mary Quarterly*, 3rd Series, Vol. 56, No. 2, April 1999, 307 - 334.

Lee, Valerie. *Granny, Midwives & Black Women Writers: Double-Dutched Readings*. New York: Routledge, 1996.

Lefever, Harry G. "Leaving the United States: The Black Nationalist Themes of Orisha-Vodu." *Journal of Black Studies*, Vol. 31, No. 2 (November 2000),

174-195.

Lester, Julius. *Black Folktales.* New York: Grove Press, 1969.

Lester, Julius and George Woods. "Black and White: A Exchange." *Black Perspectives* 66-72.

Lewis, David Levering. *When Harlem Was Vogue.* New York: Oxford University, 1989.

Liddell, Janice. *Imani and the Flying Africans.* Illustrated by Linda Nickens. Trenton: Africa World Press, 1994.

*Life.* "Realism in a Book about Black Children; Stevie." August 29, 1969, 54-59.

Locke, Alain, ed. *The New Negro: An Interpretation.* New York: Johnson Reprint Corporation, 1925.

Lorde, Audre. "I Am Your Sister: Black Women Organizing Across Sexualities."

Lyells, Ruby E. "Reviews." *The Library Quarterly,* October 1941, 516-518.

MacCann, Donnarae and Olga Richards. *The Child's First Book; A Critical Study of Pictures and Texts.* New York: The H.W. Wilson Company, 1973.

Marvin, Thomas F. "Children of Legba: Musicians at the Crossroads in Ralph Ellison's Invisible Man." *American Literature,* 68, 3, September 1996, 587-608.

Mathis, Sharon Bell. "Who Speaks for a Culture." *Reading, Children's Books, and Our Pluralistic Society,* edited by Harold Tanyzer and Jean Karl, Newark: International Reading Association, 1972, 30-33.

Mayfield, Julian. "You Touch My Black Aesthetic and I'll touch Yours." *The Black Aesthetic.* Ed. Addison Gayle, Jr., 31-37, New York: Anchor Books, 1971.

Medina, Tony. *DeShawn Days.* Illustrated by R. Gregory Christie. New York: Lee & Low, 2001.

Mendez, Phil. *The Black Snowman.* Illustrated by Carole Byard. New York: Scholastic, 1989.

Milender, Dharathula H. "Through A Glass Darkly." *School Library Journal* (December 15, 1967) 32.

Mitchell, Arlene Harris and Darwin L. Henderson. "Black Poetry: Versatility of Voice." *English Journal.* April 1990, 28.

Mitchell, Margaree King. *Uncle Jed's Barbershop.* Illustrated by James Ransome.

New York: Scholastic Inc.,1993.

Moore, Opal. "Picture Books: The Un-Text." *The Black American in Books for Children; Readings in Racism*, edited by Donnarae MacCann and Gloria Woodard, New Jersey: Scarecrow Press, 1985.

Morrison, Toni. *Song of Solomon*. New York: Penguin, 1977.

Murray, Albert. "The Omni Americans." *The Urban Review*, June 1969, 38-45.

———. *The Omni Americans; New Perspectives on Black Experience and American Culture*. New York: Outerbridge & Dienstfrey, 1970.

Myers, Walter Dean. *Harlem*. Illustrated Christopher Myers. New York: Scholastic, Inc., 1997.

———. "Telling Our Children the Stories of Their Lives." *American Visions*, December 1991, 30-32.

———. "How I Came to Love English Literature." *English Journal*, November 1985, 93-94.

———. "Let Us Celebrate The Children." *The Horn Book Magazine*, January 1990, 46-47.

———. *Malcolm X, By Any Means Necessary; A Biography*. New York: Scholastic, Inc., 1993.

Neal, Larry. *Visions of a Liberated Future; Black Arts Movement Writings*. New York: Thunder's Mouth Press, 1989.

Oliver, Paul. *Blues Fell This Morning: The Meaning of the Blues*. New York: Horizon Press, 1960.

Parks, Carole A. "Goodbye Black Sambo; Black Writers Forge New Images in Children's Literature." *Ebony*, November 1972, 60-70.

Patton, Sharon F. *African-American Art*. Oxford: Oxford University Press, 1998.

Peart, Norman A., Elizabeth P. Pungello, Frances A. Campbell, & Thomas G. Richey. "Faces of Fatherhood: African American Young Adults View the Paternal Role." *Families in Society*, Vol. 87, No 1, Jan/March 2006, 71-83.

Powell, Richard J. *Black Art And Culture in the 20th Century*. New York: Thames and Hudson, 1997.

———. *The Blues Aesthetic: Black Culture and Modernism*. Washington D.C.: Washington Project for the Arts, 1989.

Preer, Bette Banner. "Guidance in Democratic Living through Juvenile Fiction." *Wilson Library Bulletin*, May 1948, 677-708.

Randall, Dudley. "Ballad of Birmingham." *The Black Poets*, edited by Dudley Randall. New York: Bantam Books, 1971.

Ray, Benjamin C. *African Religions; Symbol, Ritual, and Community*. New Jersey: Prentice-Hall, Inc., 1976.

Redmond, Eugene. *Drumvoices: the Mission of Afro-American Poetry: a Critical History*. Garden City: Anchor Press, 1976.

Rider, Ione Morrison. "Arna Bontemps." *The Horn Book Magazine*, January/February 1939, 13-19.

Ringgold, Faith. *Tar Beach*. New York: Crown Publishers, Inc., 1991.

Rollins, Charlemae. "Promoting Racial Understanding Through Books," *Negro American Literature Forum For School and University Teachers*, Winter 1968, 71-74.

Rose, Tricia. *Black Noise: Rap Music and Black Culture in Contemporary America*. Hanover NH: Wesleyan University Press, 1994.

Salaam, Kalamu ya. "It didn't Jes Grew: The Social and Aesthetic Significance of African American Music." *African American Review*, Vol.29, No. 2, Summer 1995, 351-375

——. *What is Life? Reclaiming the Black Blues Self*. Chicago: Third World Press, 1994.

Schwartzman, Myron. "Of Mecklenberg, Memory, and the Blues: Romare Bearden's Collaboration with Albert Murray." *Bulletin of Research in the Humanities*, 86, Summer 1983, 140-160.

Shange, Ntozake. *For Colored Girls Who Have Considered Suicide When the Rainbow is Enuf*. New York: MacMillan Publishing Co., 1977.

——. *i live in music*. Illustrated by Romare Bearden. New York: Stewart, Tabori & Chang, 1994.

Small Jr., Robert C. "*South Town*: A Junior Novel of Prejudice." Negro American Literature Forum, Winter, 1970, 136-141.

Smith, Anita Hope. *The Way a Door Closes*. Illustrated by Shane W. Evans. New York: Henry Holt and Company, 2003.

Steele, Shelby. "Ralph Ellison." *Journal of Black Studies* 7, (December 1976): 151-168.

Steptoe, Javaka. *In Daddy's Arms I am Tall; African Americans Celebrating Fathers*, New York: Lee & Low Books, Inc., 1997.

Steptoe, John. *Birthday*. New York: Harper & Row, Publishers, 1972.

———. *Stevie*. New York: Harper & Row, Publishers, 1969.

———. *Uptown*. New York: Harper & Row, Publishers, 1971.

Stevens, Jane Ellen. "Zebras in Turmoil." *International Wildlife*, Vol. 24, S/O 1994, 4-13.

Stewart, Jeffrey. "Given the Blues." Edited by Richard J. Powell, *The Blues Aesthetic: Black Culture and Modernism*. Washington D.C.: Washington Project for the Arts, 1989.

Sunshine, Catherine A. *Caribbean: Survival, Struggle and Sovereignty*. Boston: South End Press, 1988.

Tarry, Ellen and Marie Hall Ets. *My Dog Rinty*. Illustrated by Alexander and Alexandra Allard. New York: Viking Press, 1946.

Teish, Luisah. *Carnival of the Spirit*. San Francisco: Harper & Row, 1994.

Tracy, Steven C. "The Blues in Future American Literary Histories and Anthologies." *MELUS*, 10, 1, Spring 1983, 15-25.

Williams, Sherley Anne. "Returning to the Blues: Esther Philips and Contemporary Blues Culture," *Callaloo*, Vol. 14, No. Autumn, 1991, 816 – 828.

———. *Working Cotton*. Illustrated by Carole Byard. New York: Harcourt Brace Jovanovich, Publishers, 1992.

Woodson, Jacqueline. *Coming on Home Soon*, illustrated by E. B. Lewis. New York: Putnam Juvenile, 2004.

———. "Fictions," *Obsidian III* Vol. 3, No.1 Spring-Summer 2001, 49.

———. "A Sign of Having Been There." *The Horn Book*, Vol. 71, Issue 6, November 1995, 711 – 715.

———. *Visiting Day*, illustrated by James Ransome. New York: Scholastic, 2002.

Wright, Richard. *Black Boy; A Record of Childhood and Youth*. New York: Harper, 1945.

———. *Native Son*. New York: Harper, 1940.

X, Malcolm. *Autobiography of Malcolm X*. As told to Alex Haley. New York: Ballantine, 1965.

# Index